OSCAR
Style ®

THE CLASS OF 2001:
Traffic's *Benicio Del Toro (in Armani)*, Pollock's *Marcia Gay Harden (in Randolph Duke)*, Erin Brockovich's *Julia Roberts (in Valentino) and* Gladiator's *Russell Crowe (in an Armani jacket)* celebrate in style.

STAFF

Editor: Richard Sanders *Photo Editor:* Ann Tortorelli *Art Director:* Gail Anderson *Designers:* Gregory Monfries, Seema Christie *Senior Editor:* J.D. Reed *Senior Writer:* Anna Holmes *Chief of Reporters:* Randy Vest *Researchers:* Abby West, Emily Hebert *Copy Editor:* Tommy Dunne *Creative Director:* Rina Migliaccio *Photo Assistant:* Urbano DelValle *Imaging Specialist:* Rebecca Gaffney *Assistant:* Patricia Hustoo *Special thanks to:* Brian Anstey, Jane Bealer, Robert Britton, Sal Covarrubias, Margery Frohlinger, Rashida Morgan, Charles Nelson, Lillian Nici, Susan Radlauer, Deborah Ratel, Mikema Reape, Patricia Rommeney, Annette Rusin, Jack Stycznski, Céline Wojtala, Patrick Yang

PEOPLE BOOKS

President: Rob Gursha *Vice President:* David Arfine *Executive Director:* Carol Pittard *Director, Retail & Special Sales:* Tom Mifsud *Director of Finance:* Tricia Griffin *Marketing Director:* Kenneth Maehlum *Assistant Marketing Director:* Vanessa Cunningham *Associate Product Manager:* Linda Frisbie *Prepress Manager:* Emily Rabin *Associate Book Production Manager:* Suzanne Janso *Special thanks to:* Robert Dente, Gina Di Meglio, Anne-Michelle Gallero, Peter Harper, Natalie McCrea, Jonathan Polsky, Mary Jane Rigoroso, Steven Sandonato, Bozena Bannett, Niki Whelan

Contents

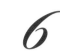

yle

IN THE BEGINNING, OSCAR WAS NO FASHION PLATE. In 1935, Claudette Colbert picked up her statuette in a simple traveling suit. Why not? She was on her way to catch a train. But what a difference the decades make. Last year, Halle Berry grabbed her award with a $3 million ring on her hand. When the red carpet rolls out March 23 for the event's 75th anniversary, it will kick off what has become the most expensive, most fabulous and most watched fashion show on the planet. "This is glamor," the designer Halston once said. "I came with a dream of what the Academy Awards were like, and I'm going home with a full stomach." Turn the page and enjoy the banquet.

An Affair to REMEMBER

ON MAY 16, 1929, 270 GUESTS GATHERED IN THE Blossom Room of the Hollywood Roosevelt Hotel for the very first Academy Awards dinner. Twelve statuettes were handed out in a mere five minutes, and since the press wasn't interested in the little event, attendees— including Mary Pickford and Douglas Fairbanks— dressed only to impress each other. Subdued gowns and drop-waisted flapper dresses were the norm. Recalled first Best Actress Janet Gaynor: "It was more like a private party than a big public ceremony."

GONE WITH THE GOLD: *No sedate gowns for Best Actress Vivien Leigh. She bucked the dullness trend at the 1940 dinner with a vibrant floral print that echoed her* Gone with the Wind *costumes.*

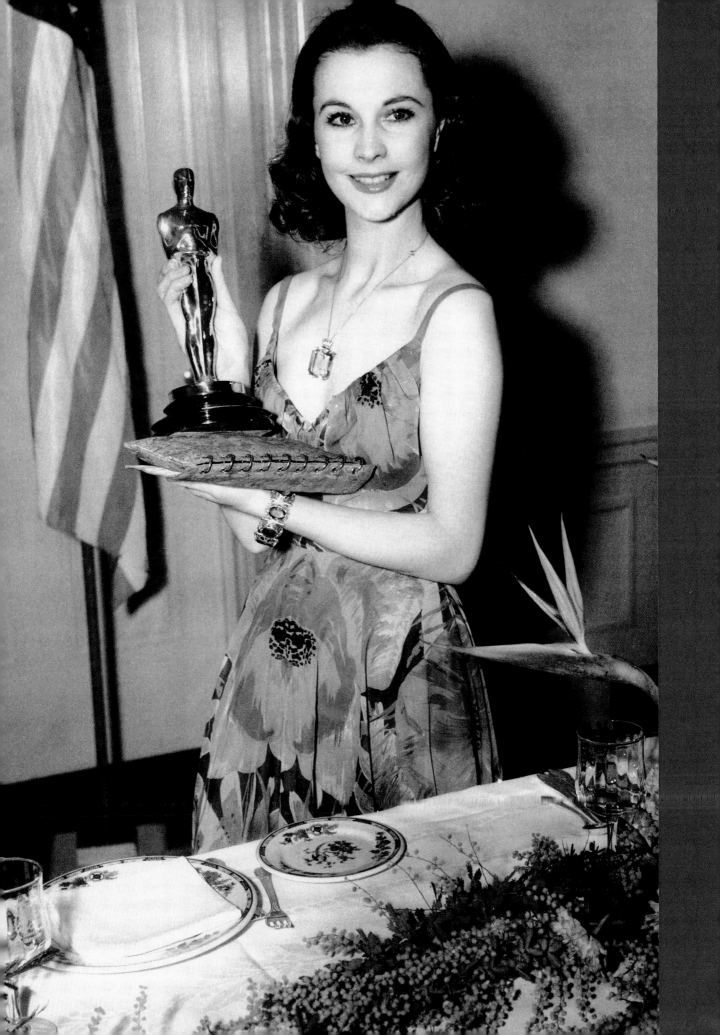

A DECADE LATER, HOWEVER, CAME A RED-CARPET revolution. In 1940, Academy president Frank Capra decided to start filming the event, and stars responded by puttin' on the ritz. Out came the silk and satin, the rocks and the furs. Vivien Leigh arrived in a floor-length ermine robe, and Olivia de Havilland created drama in a voluminous black evening gown.

Awards fashion often reflected the times. During World War II, Oscar was as patriotic as Uncle Sam.

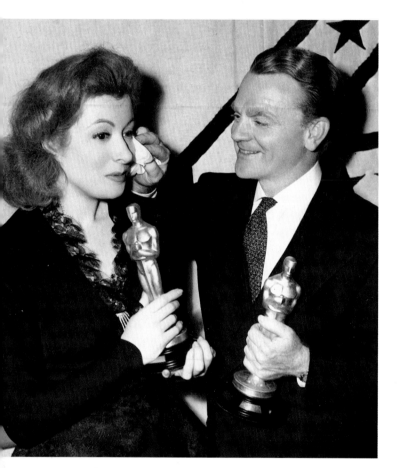

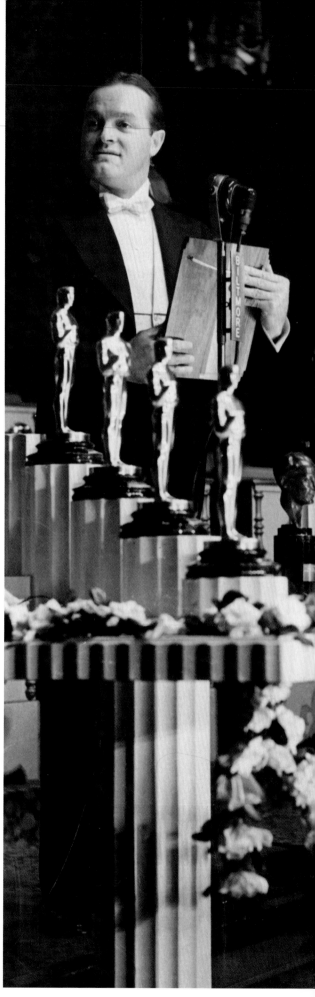

Women were requested to forgo fancy evening dress; Jimmy Stewart presented an award in 1942 wearing his Air Corps uniform. When television first focused on Oscar in 1953, the Academy was nervous about offending middle-class morality with Hollywood's casual attitude toward exposing flesh. Censors demanded attire that would play in Peoria. "I was appointed guardian of hemlines and bodices," recalled veteran costume designer Edith Head. "We couldn't trust the stars who were to go onstage. After I approved their gowns, some

would push up their cleavages just before going on."

The Awards became a fashion spectator sport in the 1960s. The decade of bra burning and microminis also saw the demise of the studio system, in which back-lot costumers often dressed their contract players for the Oscars. Rebels walked the red carpet. Cher began making fashion incursions, and even conservatives like Julie Andrews loosened up (in '66 she wore a kimono). With the Vietnam War dividing the country, disco music thumping, and bell-bottoms flashing, the Awards show got hip in the 1970s. Diane Keaton came in Annie Hall-style outfits, Sylvester Stallone wore an open shirt and a medallion on his chest, and Jane Fonda wore the same dress two years in a row—on purpose!

PERENNIAL HOST *Bob Hope (waiting to hand out the Oscars in 1941) wore attire that, like his jokes, rarely strayed from the mainstream. More of an individualist, James Cagney (with Greer Garson) showed up at the Awards in 1943 wearing a plain business suit.*

Extravagance marked the 1980s. Hair was big, jewels were big, breast implants were big. At the Oscars, certain names were big: Bob Mackie, Gianni Versace, Nolan Miller and, of course, Giorgio Armani. Now celebrities wanted their own couture camp. By 1991, *Women's Wear Daily* was calling the show "the Armani Awards." Much of the reason, said Glenn Close, was that "if you wear Armani, chances are no one will write anything negative about your dress." Perhaps, but that didn't make for fun viewing. Nor did the arrival of the stylists, who selected outfits, hair, makeup and accessories for the stars. Oscar had become a massively expensive—and bland—fashion shoot.

A decade later, Oscar style is returning to its roots, with more borrowing from vintage Hollywood. And more celebrities (albeit with the help of stylists) are finding their individual paths and expressing their true showbiz selves—flamboyant and exuberant. On the big night, both performers and viewers can relate to what Cate Blanchett, in a lavish Galliano, said in 1999: "I feel like I'm having a fashion orgasm."

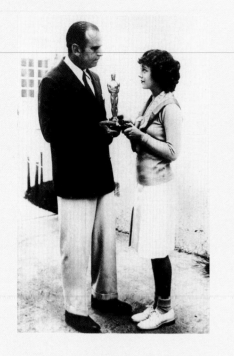

FIRST BEST ACTRESS JANET GAYNOR *came to a 1929 photo op in a flapper getup. "I was more thrilled," she said, "over meeting Doug Fairbanks" (left).*

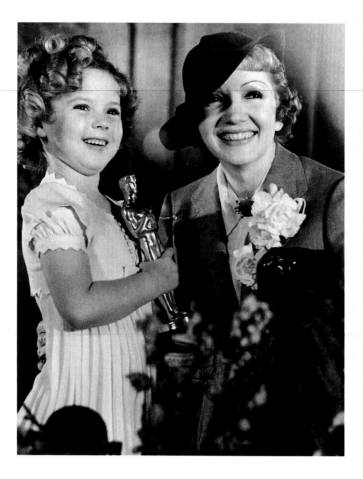

THE AWARDS *were so low-key that Best Actress Claudette Colbert spent only six minutes at the show in 1935. Presenter Shirley Temple wore a pink batiste dress showing, she said, "lots of leg."*

THE DEPRESSION *barely reined in 1935's Oscar fashion. As George Burns once said of wife Gracie Allen, "She had furs from animals that I'd never even heard of."*

NOT IN KANSAS anymore: Mickey Rooney congratulates his Love Finds Andy Hardy costar Judy Garland. Munchkin-cuddly in a rabbit fur jacket, she collected a special youth Oscar for 1939's The Wizard of Oz.

LORETTA YOUNG
*looked nothing like
the housekeeper she
played in* The Farmer's
Daughter *when she
accepted her Oscar
in emerald-green silk
taffeta in 1948.*

> '*Up to now, this occasion has been a spectator sport. But I dressed, just in case*'
>
> —LORETTA YOUNG

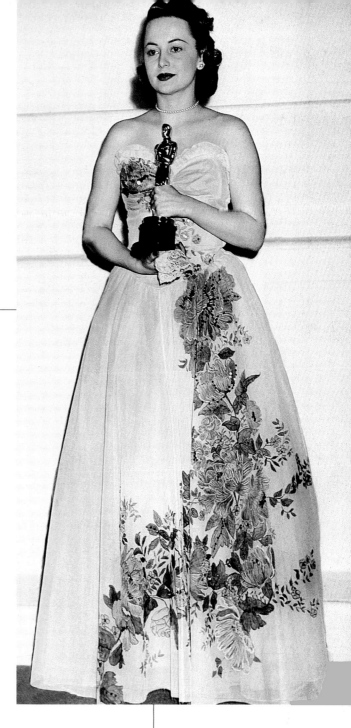

HARD TO TELL, BUT *Olivia de Havilland's pale blue organza gown was stained by gravy just before she won Best Actress in '47 for To Each His Own.*

IN 1945 INGRID *Bergman opted for open-toed sandals and—scandalous!— the same simple black dress she'd worn the year before.*

accessories was all
nominee Gloria
Swanson took home
in 1951. Moments later,
Judy Holliday was
named Best Actress.

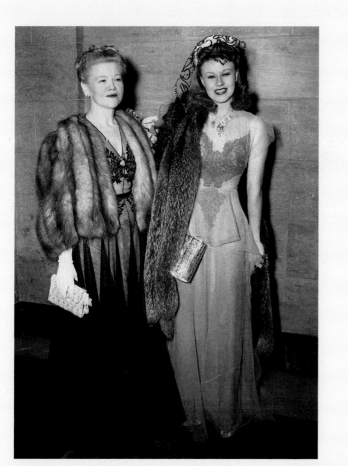

TO GO WITH HER *lingerie-inspired dress, Best Actress winner and Kitty Foyle star Ginger Rogers was dolled up with diamonds, curls, lace, fur ... and her proud mother, Lela, in 1941.*

AFTER FASHION *faux pas at two previous ceremonies, 1939 Jezebel winner Bette Davis swanned into the show in a Colette gown embellished with egret feathers.*

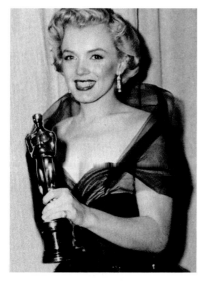

SOME LIKE IT NOT: IN HER ONLY *Oscar appearance, 1951 presenter Marilyn Monroe burst into tears after finding her black tulle gown was torn.*

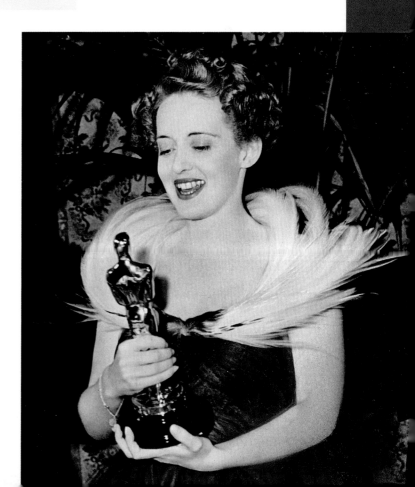

1953 3...2...1...LIVE, FROM L.A.! IN 1953 THE OSCARS were televised for the first time, drawing the new medium's largest audience to date. Favorites including Olivia de Havilland and Joan Crawford glided across the small screen swathed in postwar opulence, helping fashion to take center stage. Suddenly, who wore what became a watercooler subject. At the beginning of the '50s, though, styles tended to the demure. Worried about NBC's buttoned-down censors, the Academy asked stars to expose less flesh. It worked for a while, but by 1958 things had, well, slipped. Frustrated producer Jerry Wald issued a decree: "There will be no cleavage on this year's Oscar Awards show. This was one of the major criticisms we received last year. . . . If you need any help, a wardrobe mistress backstage is equipped with enough lace to make a mummy."

to the 1954 red-carpet bleacherettes (and 45 million viewers), the swashbuckling Kirk Douglas gave his traditional outfit panache with a hankie and a carnation.

Oscars show in '54,
Grace Kelly bubbled in
grape-embroidered
champagne tulle, while
Mogambo costar Clark
Gable called it a wrap in
a black overcoat.

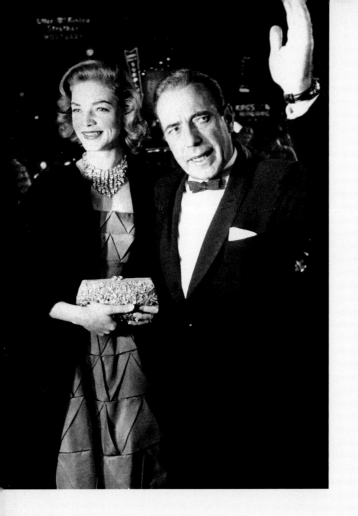

DONNA REED WON
*in '54 playing against
type as* From Here
to Eternity*'s prostitute,
but modestly played
the Oscar fashion
game by covering her
low-cut strapless
gown with a coat.*

SPLENDID IN
*patchwork taffeta,
Lauren Bacall
(with husband
Humphrey Bogart in
'55) flashed her
diamond necklace and
cracked, "You can see
where my money goes."*

ACTRESSES CLEO
*Moore (left) and Jayne
Mansfield busted out of
Hollywood in their over-
the-top Oscar best when
the 1955 Awards show
was telecast from New
York City as well as L.A.*

CINDERELLA STOOPS TO
conquer. Entering the 1953
event with second husband
Michael Wilding, Elizabeth
Taylor, angelic in a full-
skirted gown, gave an
awed fan her autograph.

A NEWCOMER IN '54, KIM NOVAK *caught the eyes of the paparazzi—and everyone else—spiced up in this sequined, body-hugging, vamped-to-the-max number.*

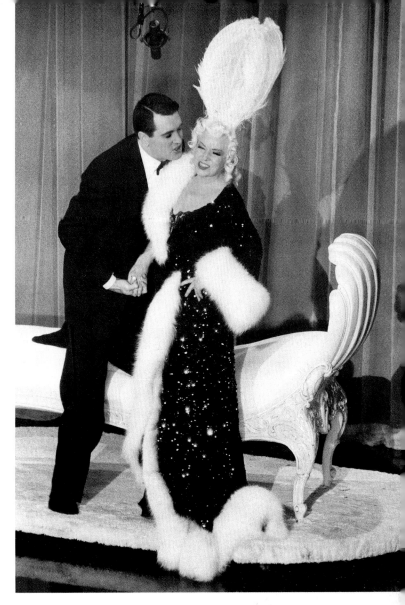

PUTTIN' ON THE *glitz—and the 1958 TV audience—with a cross-generational skit, Mae West, 64, found Rock Hudson, 32, glad to see her in her burlesque-era feathers and furs.*

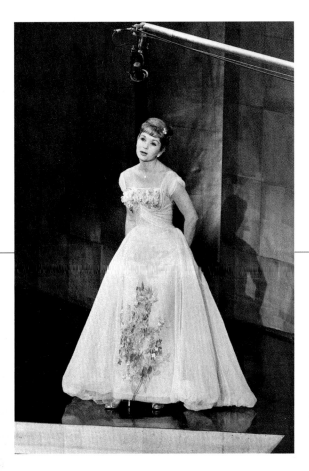

DEBBIE REYNOLDS, *sugary-sweet in a girl-next-door prom-style gown by MGM costumer Helen Rose, sang "Tammy" in '58. That year, Best Actress nominee Liz Taylor would steal Reynolds's husband, Eddie Fisher.*

1960

OSCAR STARTED TO SWING-a-ding-ding in the '60s. The reign of the studios ended, and the stars were finally free to express themselves. At the same time, a cultural revolution preached peace and love. The result: eye-popping razzle-dazzle that made the red carpet the world's premiere catwalk. Cher came on like an Egyptian, Julie Christie defied a ban on miniskirts, and Barbra Streisand wore see-through pajamas. The "Me Decade" of the '70s brought even more excesses of individuality and a new focus to the Oscars. By 1976, viewers cared more about the clothes than the awards. "So we are paying strict attention this year to giving the public what it wants," said producer Howard W. Koch. Yeah, baby!

LEE REMICK (WITH *Roddy McDowall*), *who won plaudits in* Days of Wine and Roses, *chose nights of stripes and spangles for the 1967 event with this busy strapless caftan.*

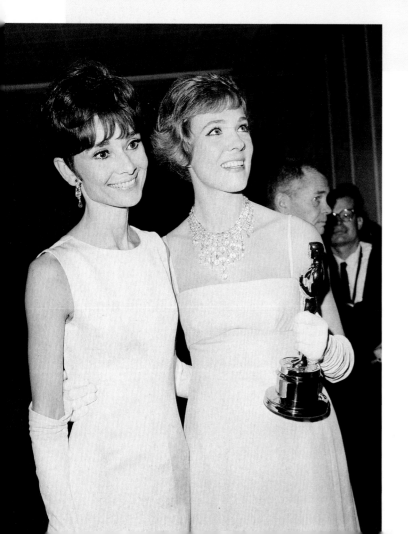

IN '65, FAIR LADIES *Julie Andrews (right), Broadway's Eliza Doolittle, and Audrey Hepburn, the screen Eliza, shared an elegant simplicity in similar gowns and opera-length gloves.*

AFTER ANNE
Bancroft told 1964's
Lilies of the Field
winner Sidney Poitier,
"Live it up, chum, it
doesn't last long," he
did a dazzling double
take in his crisply
perfect morning coat.

'*Suddenly I'm having to worry about my hair. I got hot rollers for the first time in my life*'

–LOUISE FLETCHER,
Best Actress,
One Flew Over the Cuckoo's Nest

"SHE WAS ONLY 10 years old, but she knew exactly what she wanted," said designer Nolan Miller of Tatum O'Neal's 1974 man-style tux. She got the idea from Bianca Jagger, Mick's then-wife.

THE MIRACLE Worker's Patty Duke, 16, accessorized her floral-embroidered ballgown with her Chihuahua Bambi, who was carried to the '63 show in a bowling bag.

LIKE, WOW. ERSATZ
*flapper Barbra
Streisand sported a
"Bob Dylan" do in '68,
while Sammy Davis Jr.
wore love beads over
his Sy Devore black
velvet Nehru jacket,
one of 20 he owned.*

NET WORTH: ANGIE Dickinson showed off her famous assets in 1976 with this spangled high-slit sheath, while composer husband Burt Bacharach played the blues in a three-piece tux and matching bow tie.

SUCCUMBING TO THE DECADE'S WRAP-
*dress rage in this magenta number, Cybill
Shepherd looked more suitable for an afternoon
tea than 1974's Oscar night of fashion.*

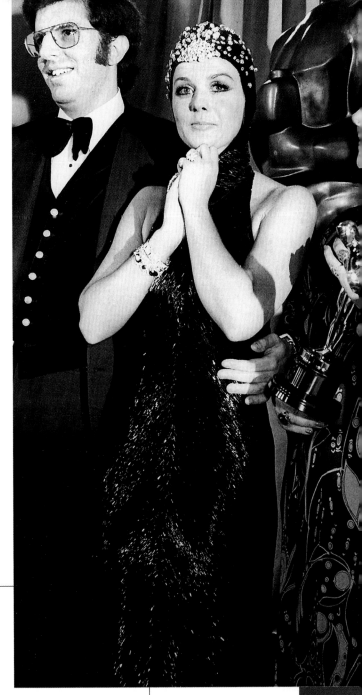

VENUS ENVY: FAYE
*Dunaway's 1968
Theadora Van Runkle-
designed black satin
dress adorned with
silk flowers and a
train was, she said,
inspired by a figure in
Botticelli's painting.*

IN 1974, ANN-
*Margret (with
composer Marvin
Hamlisch), who had
introduced Oscar
in the straight hair in
'62, went all the way
in a sequined cap and
matching outfit.*

1960-79

GLIMMER TWINS:
*Elke Sommer paid
style homage
to Oscar in 1968 in
a golden beaded
floor-length sheath.*

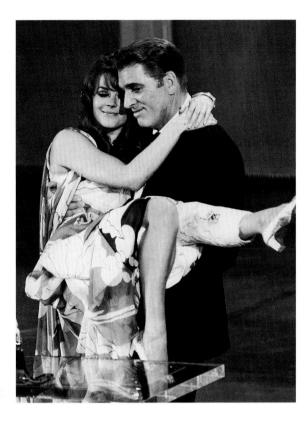

'I wanted something very simple that didn't look like a nightgown'

—MERYL STREEP,
on what she was looking for
in an Oscar dress

SPLENDOR IN THE
*cast: After breaking
her leg in an Austrian
skiing accident, a
hobbled Natalie Wood,
in a bright floral-
print dress, got a lift
from 1969 copresenter
Burt Lancaster.*

POP MUSIC'S
*Mama Cass must
have been California
dreamin' when she
picked out this
unflattering and off-
key Empire-waisted,
floor-length striped
outfit for the Awards
show in 1969.*

Stevens helped Oscar lighten up on primness in 1967. Her then-popular beehive do was as high as her hemline.

JULIE CHRISTIE'S *1967 polka-dotted chiffon minidress, deemed too risqué by many viewers, prompted the Academy to implore invitees to stick to the dress code.*

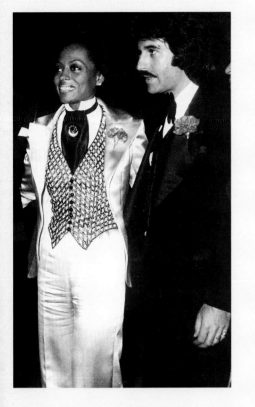

PRESENTER DIANA ROSS (WITH THEN-*husband Robert Silberstein) was Supreme-ly shining in her 1973 version of menswear: a Bob Mackie silver silk tuxedo worn with a rhinestone vest and a black ascot.*

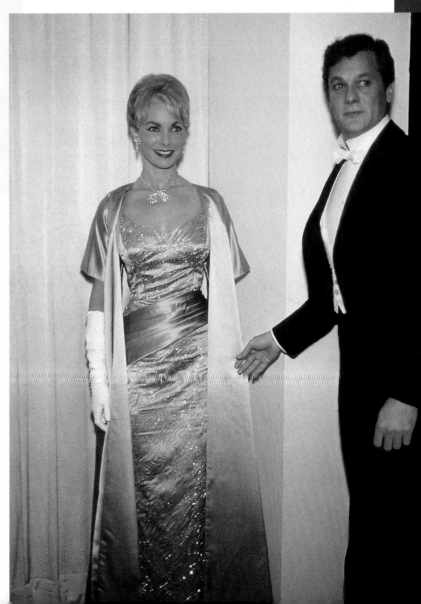

1961 BEST SUPPORTING *Actress nominee Janet Leigh (with then-husband Tony Curtis) looked anything but psycho in this lavender satin Edith Head with sash and gloves.*

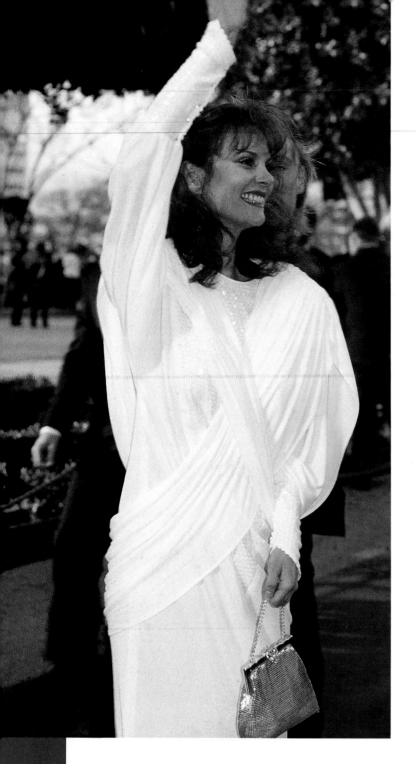

1980

THE RULES OF OSCAR FASHION changed in 1980. Abruptly, and delightfully for viewers, there were no rules. All bets were off in the decade of conspicuous consumption. Always a bellwether of edgy glamor, Cher went style-stratospheric in the '80s, and a passel of new names were being heavily dropped on the red carpet: Fabrice, Fred Hayman, Bill Hargate and Bob Mackie, among many others. The couture designers had discovered Oscar's selling power and began offering the stars free clothing if they would mention its creators. The practice made the Oscar preshow a permanent attraction. The designers' triumph was so complete that by 1985 Steve Martin joked, "I just drove up hoping to be on the pre-Oscar show. Everybody knows this is where the excitement really is."

IT WAS A WRAP FOR *Lesley Ann Warren in 1983 in this expansive white gown with crisscrossed front panels and oh-so-'80s padded shoulders.*

"SHE WAS TRYING *not to look too serious. She didn't want to look like she expected the Oscar," said designer Bob Mackie of Best Actress Sally Field's '80 ivory suit and floral beaded chiffon blouse.*

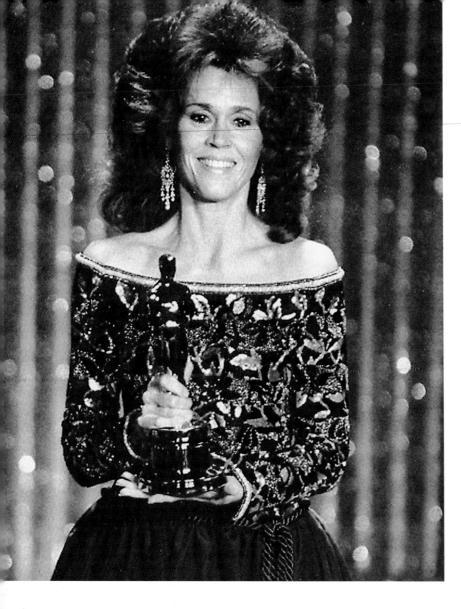

BIG NIGHT! BIG HAIR!
Jane Fonda, accepting
father Henry's Best Actor
award in 1982, was the
perfect '80s fashion icon
in an off-the-shoulder
beaded Valentino gown
with full skirt.

HER 1981 OUTFIT
of evening pants and
blouse was in the
perfect shade of black
for Sissy Spacek's
Oscar-winning
portrayal of country
music's Loretta Lynn in
Coal Miner's Daughter.

LAUREN HUTTON COMBINED
the decade's flair for flash and fitness,
arriving at the 1980 Awards in a gold
lamé sweatshirt and shorts by Zoran.

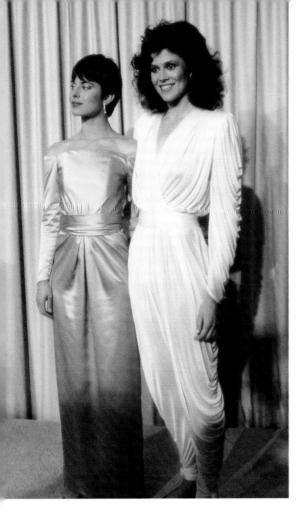

'I hope my earrings
don't fall off.
That's the only thing I'm
nervous about'

—SIGOURNEY WEAVER

NASTASSJA KINSKI'S
*understated seashell-
pink satin gown was
upstaged by fellow
1981 costume-design
presenter Sigourney
Weaver's dramatically
gathered cream-
colored pantsuit.*

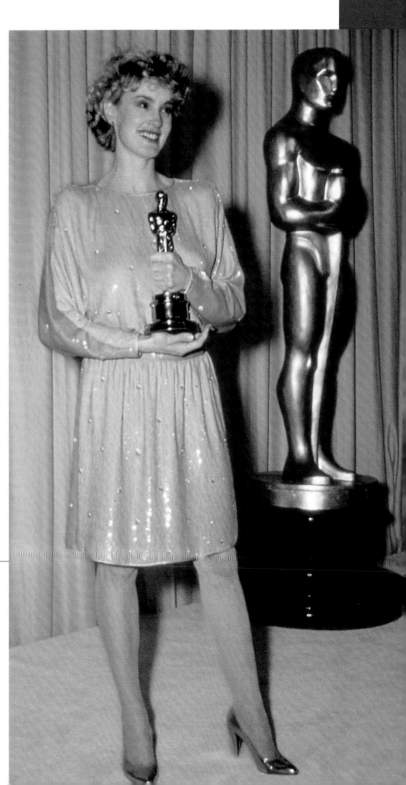

TOOTSIE SUPPORTING
*Actress winner Jessica
Lange went for the short
subject award in 1983 in
this above-the-knee
Valentino, dusted with
sequins and scatter
diamonds.*

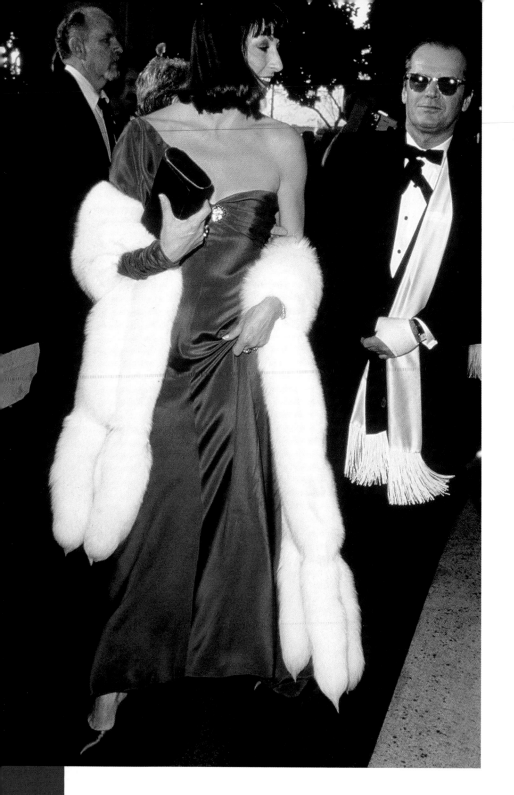

THE STATUESQUE Anjelica Huston (with Jack Nicholson in tow) designed this emerald-green gown herself and accessorized with a white fur stole for the 1986 festivities.

"THE BOW WAS right in step with what was hot!" Marlee Matlin said of her up-to-the-minute strapless gown, bought off the rack at Neiman Marcus in 1988.

'I hope people don't think it's fashion. It isn't. It's like dressing a character in a movie'

—BOB MACKIE, on designing for Cher

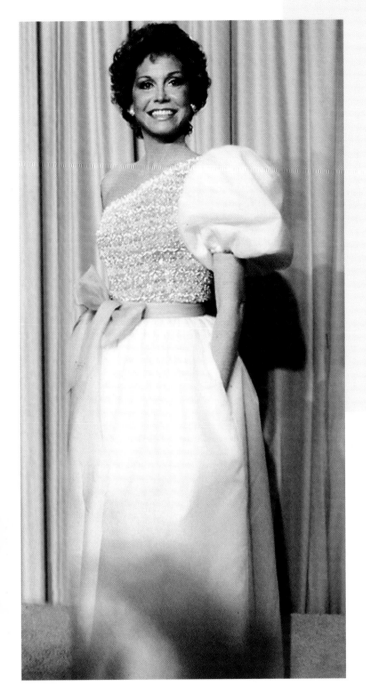

BEFORE ROUGHING
it as Dr. Quinn, Medicine
Woman, Jane Seymour
(in 1981) was red-hot in a
one-shouldered gown
with silver fringe and
seriously side-swept hair.

OH, MARE! MARY
Tyler Moore broke type
in 1981 with one-off
the-shoulder lavender-
and-white gown. The
puffy sleeves and
waist-wrapped bow?
Eighties all the way.

MARY ELIZABETH
Mastrantonio continued
the gift-wrap theme in
1987 with this white
low-waisted gown with
bateau neckline,
dropped skirt and, of
course, oversize bow.

NO ONE NEEDED a guiding light to find '80s icon Joan Collins. She shone in a red bugle-beaded halter top with black skirt by Ron Talsky and Carole Little at the 1984 show.

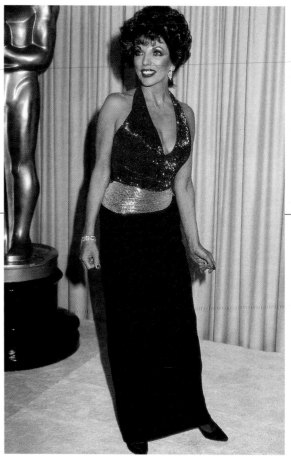

OLIVIA NEWTON-John (with then-husband Matt Lattanzi) could have sung "Beauty School Dropout" in this 1989 black satin dress with buttons up the bodice.

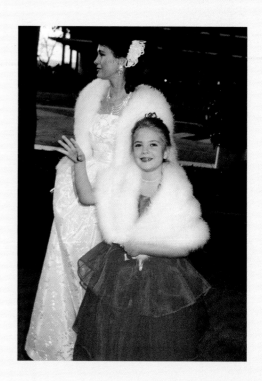

DREW BARRYMORE (8, WITH MOTHER JAID) says she has "wonderful memories" of "that frilly pink dress" she wore in 1983, post-E.T.

IT WAS HIS-AND-
her hair night in 1989
for Don Johnson and
Melanie Griffith, whose
Southern belle dress by
David and Elizabeth
Emanuel expertly hid
her 3-month pregnancy.

1980-89

1990

GIORGIO ARMANI NEVER won an Oscar, but for much of the '90s his name and those of other notable designers were on everyone's lips—and hips. They gave the affair something new: understated elegance and muted grace. "There was not one person," said hairstylist José Eber in 1993, "who made you say, 'My God, what has she done to herself?'" But too much good taste can be, as designer Arnold Scaasi said, "boring, boring, boring!" Not to worry. The new decade brought a return to romance and individuality. Over the years, we might forget who won or lost, but the stars, said style consultant Fred Hayman, "will be remembered for what they wore."

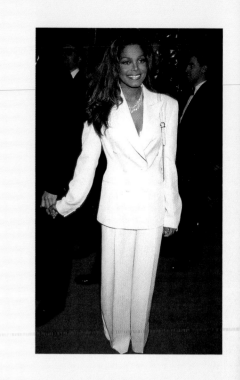

JANET JACKSON WAS IN *control in 1994 in this double-breasted suit with palazzo pants by Richard Tyler. The $400,000 Van Cleef & Arpels diamonds didn't hurt either.*

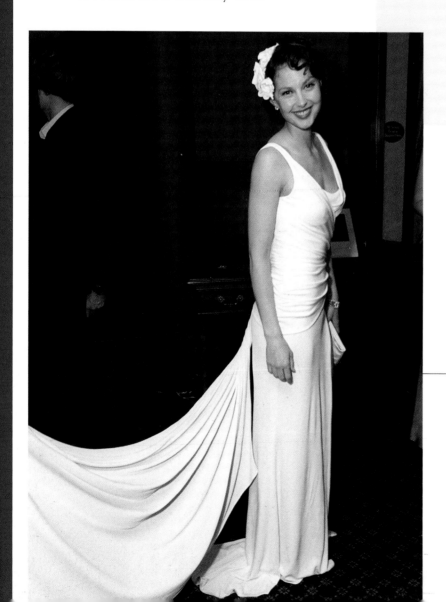

ASHLEY JUDD *wasn't keeping many divine secrets of her sisterhood in 1998, when she wore an ivory Richard Tyler jersey dress slit startlingly high up her thigh.*

IT MAY BE AN OXYMORON, BUT
*Courtney Love looked almost virginal at
the 1996 Awards in a white chiffon Versace
with deep neckline and tiny fishtail train.*

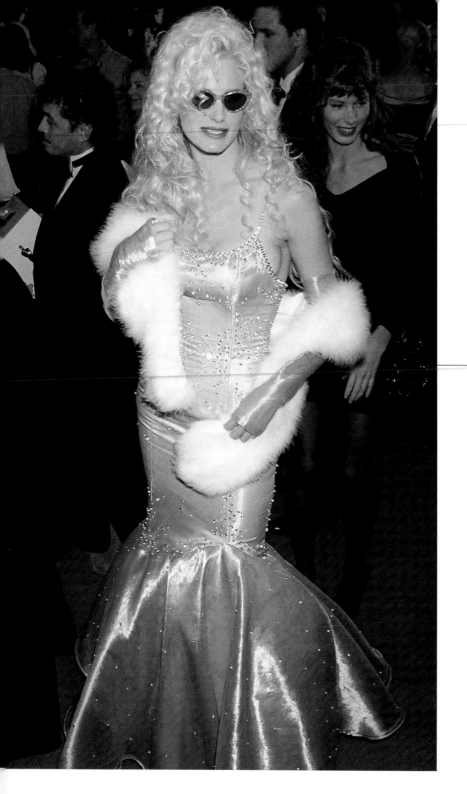

DARYL HANNAH
was all Hollywood mermaid in this gold lamé trumpet dress and white boa, a 1930s style that didn't translate well to 1990.

MADELEINE STOWE
garnered raves in 1994 for her clingy Calvin Klein gown with gold sequins and a sexy V neck.

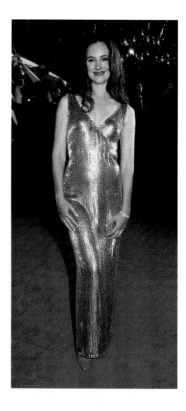

'I have a big fear that Joan Rivers will come flying across the parking lot and tell me how hideous my outfit is'

—K.D. LANG

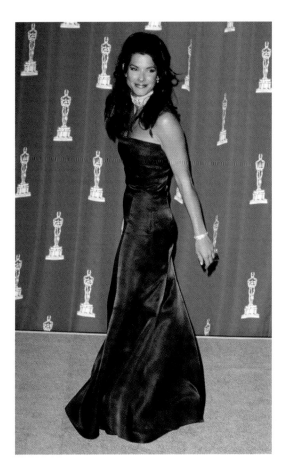

COMBINING HER LONG, SHINY RAVEN
hair with a thick diamond choker and a
strapless satin gown by Calvin Klein, Sandra
Bullock was 1996's Miss Congeniality.

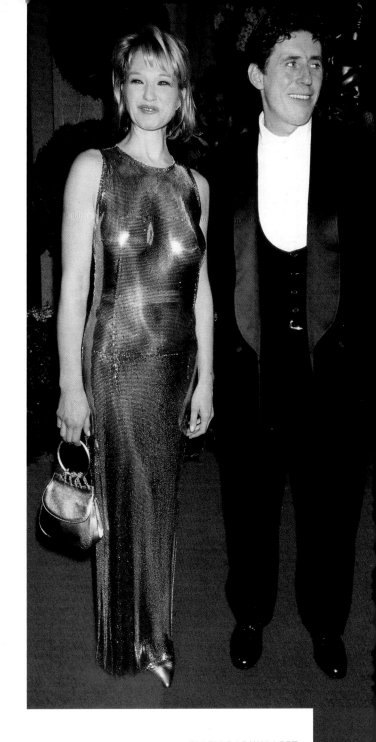

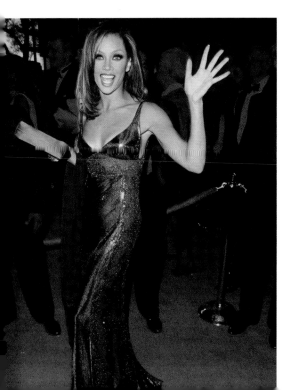

ELLEN BARKIN LEFT
little to the imagination,
going braless in this
metallic Versace in 1994.
Her gown had style
critics and then-husband
Gabriel Byrne floating
on a sea of love.

"I WAS BREATHLESS."
So said Gianni Versace
in 1996 after seeing
gorgeous Vanessa
Williams in his metallic
gown with mesh
sides and beading.

1990–2002

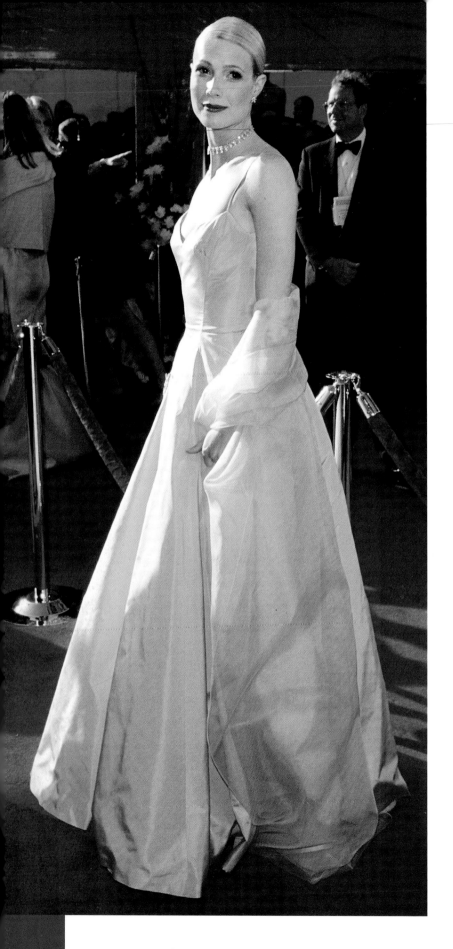

KRISTIN SCOTT THOMAS'S 1997 *black-and-chocolate silk Christian Lacroix ballgown with shawl collar and bustle was elegant and somehow, don't you know, veddy English.*

TO COMPLEMENT *her dark hair and eyes, Juliette Binoche picked a sumptuous velvet Sophie Sitbon in 1997 that was, yes, the perfect color of chocolat.*

THOUGH SHE'D ALREADY BEEN DUBBED A FASHION ICON *by the style press, Gwyneth Paltrow's badly fitted pink satin 1999 Ralph Lauren disappointed the great expectations of fashion fans.*

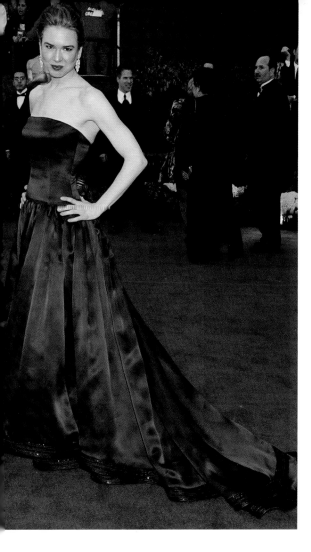

'It's the tightest
of the tightest. It gives
very good butt'

—ELLEN BARKIN, of her L'Wren Scott gown

RENEE ZELLWEGER'S
*fashion choices aren't
the most consistent,
but she showed us the
money in 2002 with
a midnight strapless
Carolina Herrera.*

GULP FICTION:
*1999 presenter Uma
Thurman picked a
two-piece platinum-
colored Chanel with
full skirt and halter
top—and a daringly
exposed tummy.*

NAOMI WATTS *showed plenty of drive in her Oscar debut in 2002. She called her black Gucci with corset top and spaghetti straps "sophisticated in sort of a punk-rock way."*

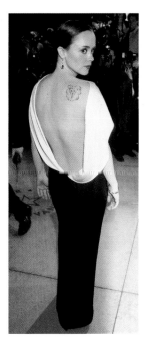

CHRISTINA RICCI *wore a backless, draped silk jersey Richard Tyler to the Awards in 2000. Her accessories: shoulder art, a chignon and a knowing look.*

JENNIFER TILLY'S 1995 BLUE-BLACK ISAAC *Mizrahi was so nice, it showed up twice. Fortunately, supermodel Vendela's version came in raspberry.*

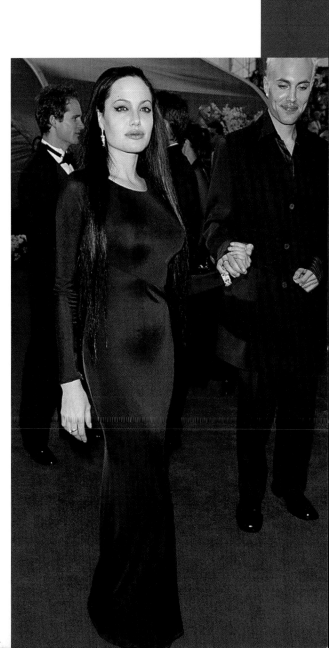

ANGELINA JOLIE *picked up her Best Supporting Actress Oscar in 2000 in an ink-colored gothic long-sleeve Versace with train. "It's silky and very me," she said. No argument.*

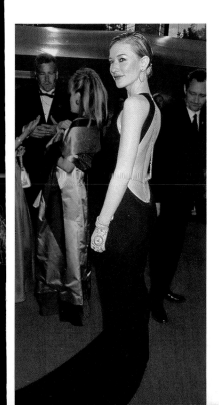

CATE BLANCHETT *lorded it over the ceremonies in 2000 with this jewel-beaded silk jersey halter dress from Jean Paul Gaultier. "It fit me well," she said. Again, no argument.*

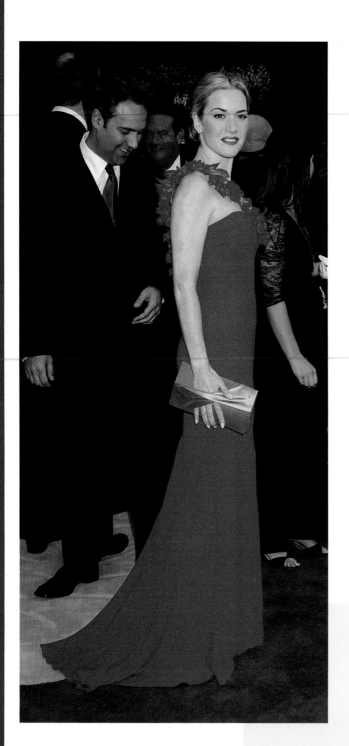

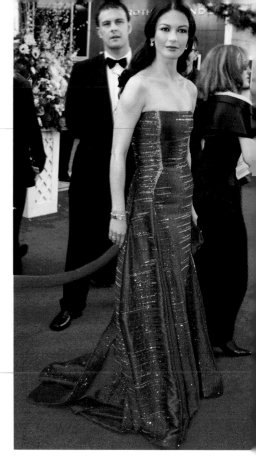

ONCE CATHERINE ZETA-
Jones saw this 1999 Versace
couture gown in a Paris show,
she knew it was the one. "It
was like what I used to dream
about wearing," she said.

ONE OF THE LADIES
in red, Kate Winslet
showed her fashion
sense and sensibility in
2002, wearing a tomato-
red Ben de Lisi chiffon
gown with a silk-rose-
garland shoulder strap.

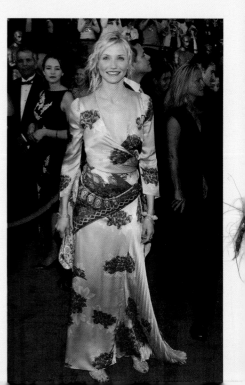

IN 2002, CAMERON
Diaz belted her floral-
print Ungaro couture
gown with a 19th-
century Indian
necklace. She later
said, "I feel like I just
got out of bed and
threw it on."

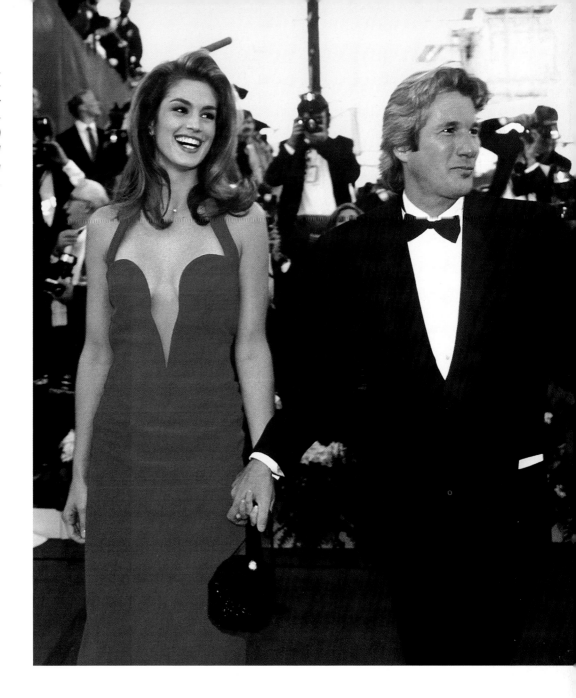

THE UP-TO-HERE, down-to-there, four-alarm Versace Cindy Crawford (with then-boyfriend Richard Gere) squeezed into in 1991 was flown in from Milan for the big night.

ANGELA BASSETT didn't have to wait to exhale to fit into her strapless satin Escada gown in 2000. Said she: "I had walking pneumonia, so I lost a few pounds."

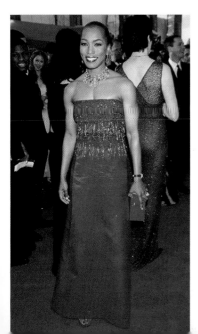

'It's not the most comfortable dress I've ever worn, but I can eat in it'

—JENNIFER LOPEZ

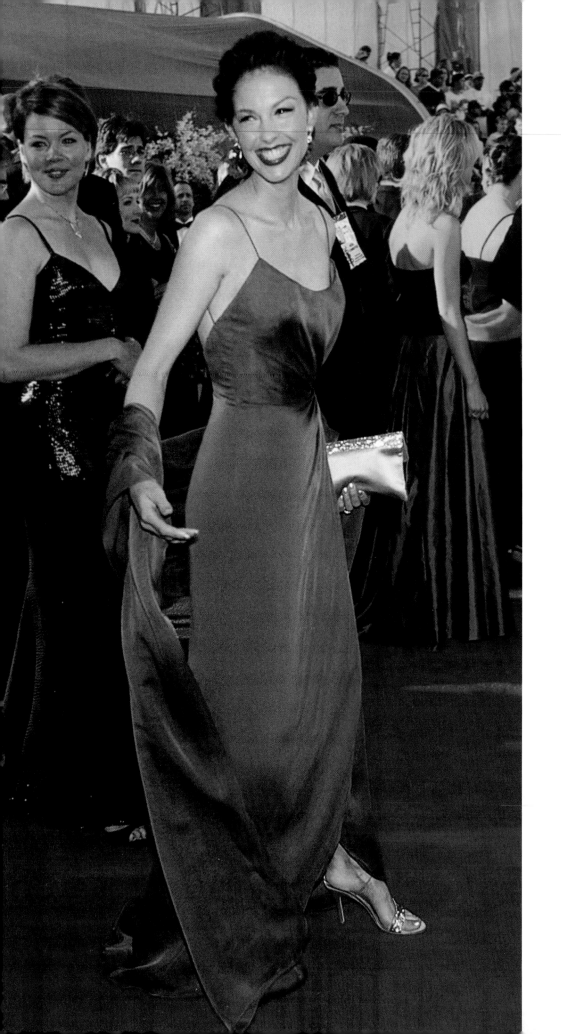

ASHLEY JUDD, IN *a stunning draped Valentino, avoided double jeopardy in 2000 when she said, "I don't know if I've ever seen such an array of loveliness."*

A *PRIMARY COLORS* NOMINEE IN
1999, Kathy Bates preferred this dove-gray gown-
and-coat ensemble from Dana Buchman.

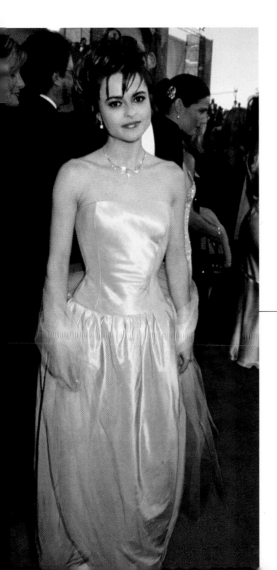

WITH HER BEADED
*Randolph Duke sparkling
bateau-neck top and
coordinating origami satin
dance skirt, Lisa Kudrow was
fashion-friendly in 1999.*

HELENA BONHAM
*Carter, Best Actress
nominee in 1998 for*
The Wings of the Dove,
*chose this silk taffeta
ballgown by Deborah
Milner because "it's
sort of lilac and gray
at the same time."*

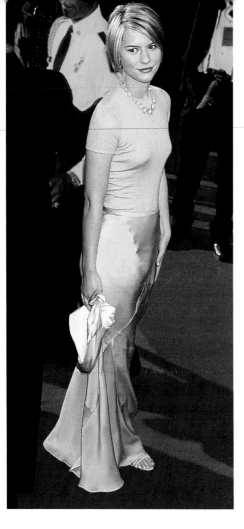

HER SO-CALLED
*life took a real
upturn in 1997, when
Claire Danes wore
this Narciso Rodriguez
set: a cashmere
sweater paired with a
silk charmeuse skirt.*

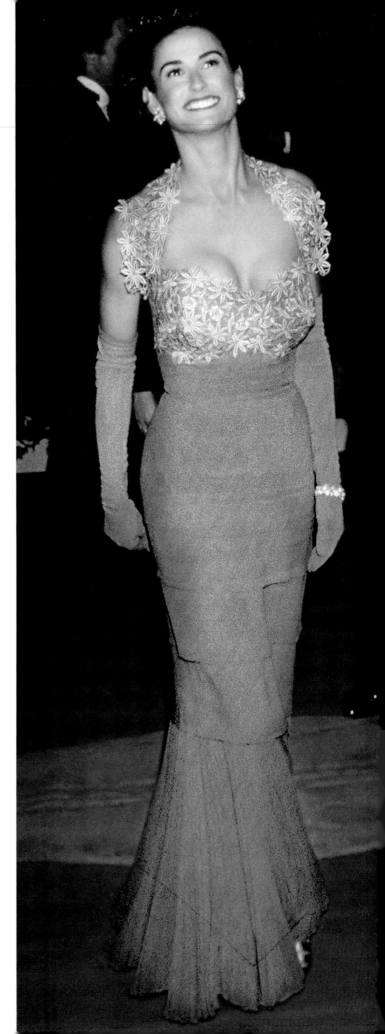

D-CUP DISCLOSURE:
*Demi Moore found her
1992 body-hugging
lavender '40s dress
with lace-appliqué
bodice and long gloves
at L.A.'s vintage
boutique Lily et Cie.*

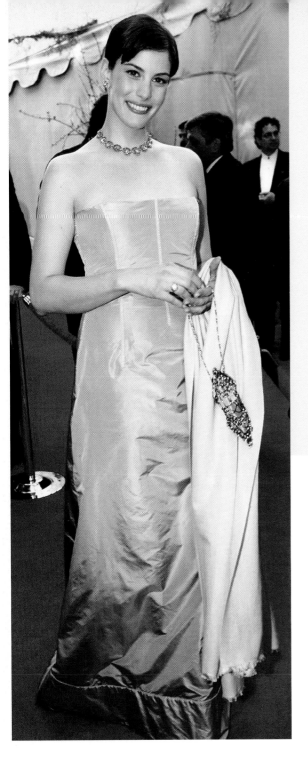

"CUTEST OF THE evening." Those were the words critics awarded Anna Paquin's 1994 outfit of a blue taffeta gown and beaded beret.

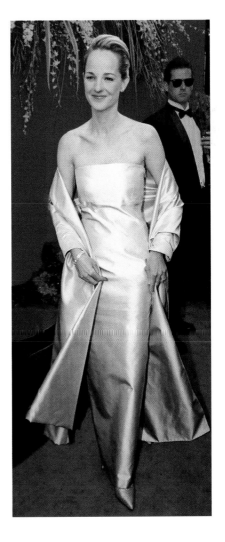

"IT'S SUCH A SCARY thing, worrying about what you're going to look like," Liv Tyler said in 1999. Not to worry: Her strapless lavender Pamela Dennis gown made the grade.

HELEN HUNT'S PALE-blue satin strapless Gucci column dress was as good as it got. "I saw it, I liked it, and I wore it," said the Best Actress Oscar winner at the 1998 show.

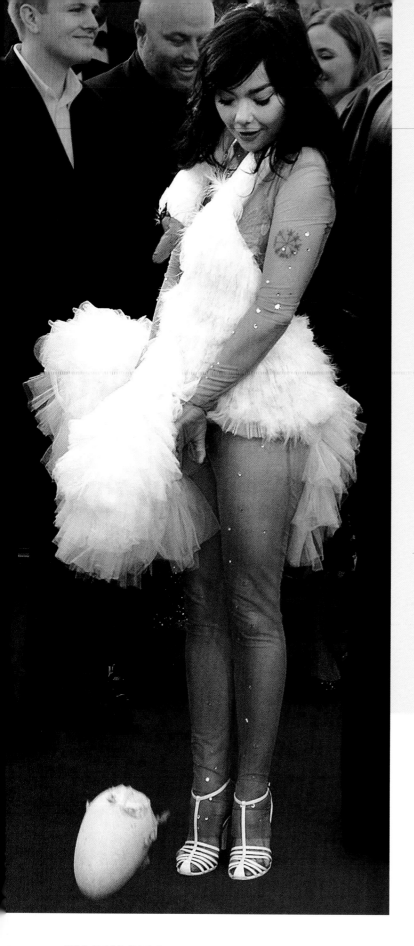

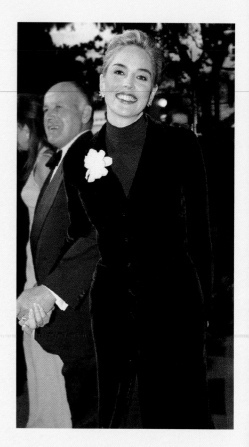

MAYBE IT WAS BASIC FASHION *instinct, but Sharon Stone (who caused a stir in '96 by wearing the cheap Gap mock turtle-neck above) claimed that the man's button-down shirt below, worn with a Vera Wang skirt in 1998, belonged to her husband,* San Francisco Chronicle *honcho Phil Bronstein.*

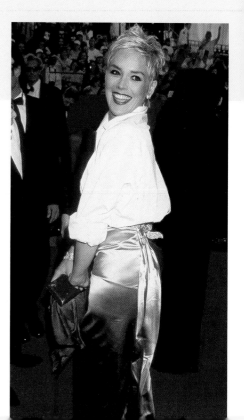

EGG-DROP SWOOP: BJORK STAGED A SWAN SONG IN 2001 *with this high-flying outfit by Marjan Pejoski. The papier-mâché egg doubled as a purse, and, yes, both produced critical squawking.*

'You look forward to it; you get your party dress, you hope your shoes fit, and then it's gone. It's like a dream'

–DIANNE WIEST

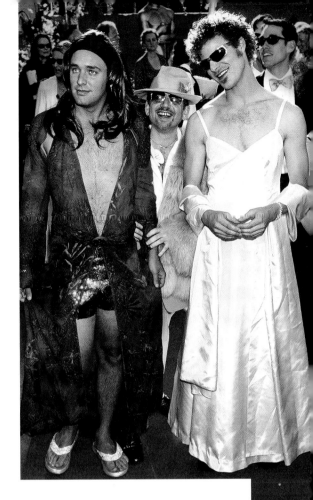

SOUTH PARK creators Trey Parker (left) and Matt Stone, who were almost barred by Academy security crews in 2000, spoofed the gowns of J.Lo and Gwyneth.

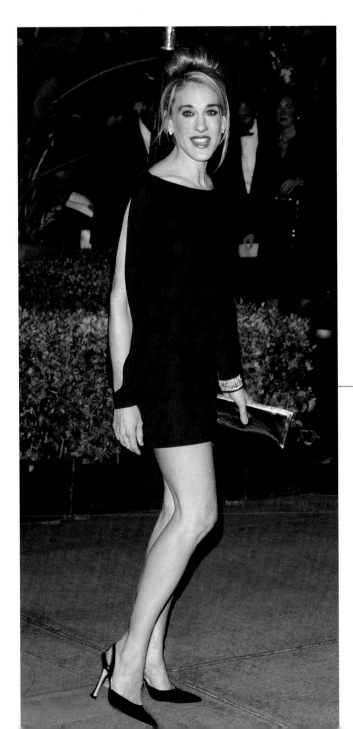

GIRLS JUST WANT *to have fun: Sarah Jessica Parker, in black jersey Calvin Klein with slit-up-the-side sleeves, said that she got ready for the 2001 show in a mere 75 minutes.*

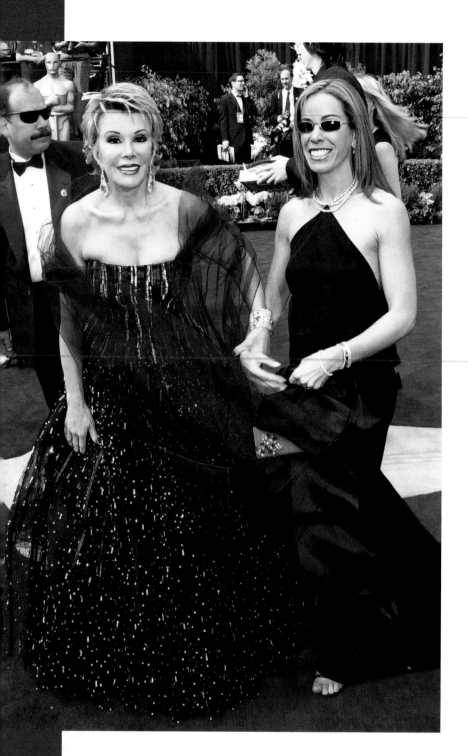

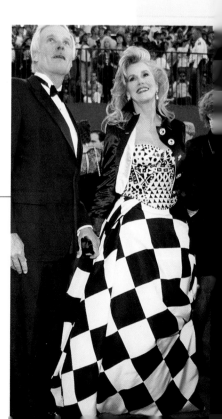

BLACK TO BASICS:
The Riverses went dark in 2002—Joan in a strapless tulle Escada ballgown, Melissa in a youthful handkerchief-halter and pearl strand.

CHECKMATE: EVEN
Jane Fonda (with then-husband Ted Turner) had problems with the checkerboard-print Versace she wore in 1995: "People walked all over [the train]."

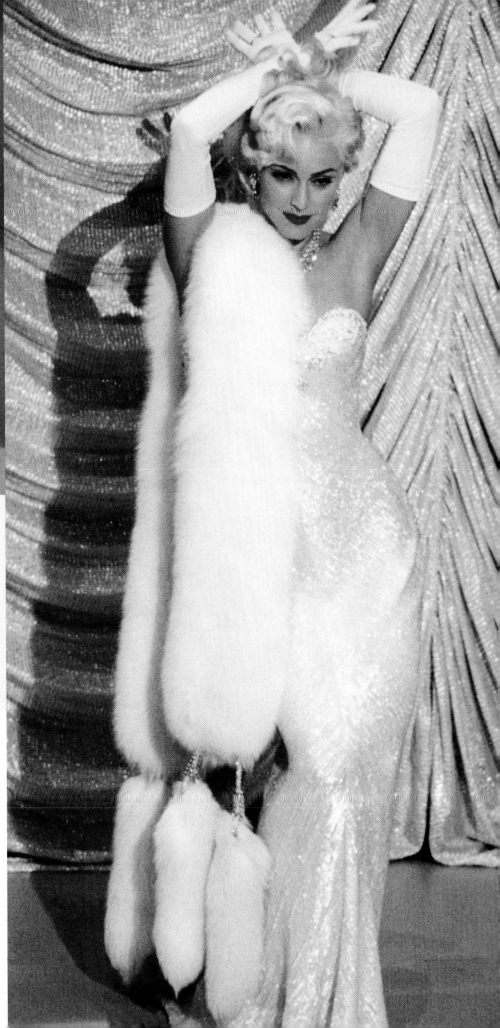

MONROE DOCTRINE:
Madonna channeled Marilyn with her 1991 strapless and sparkly white Bob Mackie, featuring a heart-shaped bodice and kid gloves—perfect for an Oscar striptease.

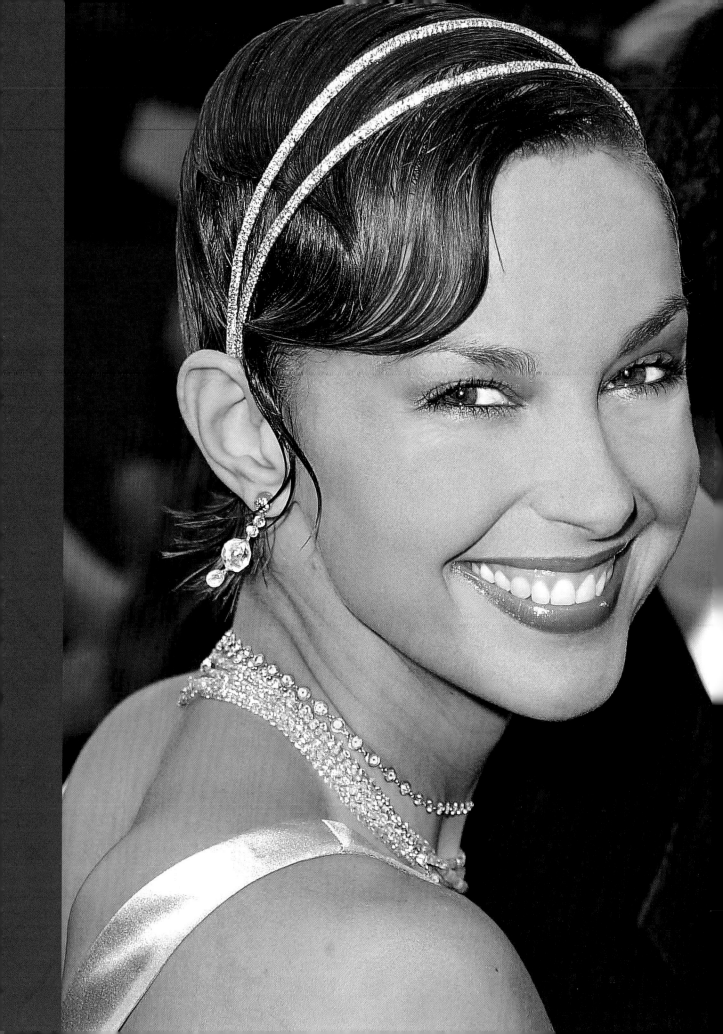

AMERICAN *Beauty*

"WHERE ELSE IS A GIRL GOING TO WEAR A TIARA IF IT'S not to the Oscars?" So Salma Hayek, clad in antique-diamond head jewelry, said in 1997, and she made a beautiful point. Not only do the Oscars give actresses a chance to experiment with fantasy and fiction, but the accessories they choose—the jewelry and hairstyles and headgear—allow them to express personal styles that aren't mandated by the houses of haute couture. Whether to enhance (like Courtney Love and Jennifer Lopez's fake eyelashes), to hide (Bette Davis's sequined gold cap, which covered up her head, shaved for her role in *The Virgin Queen* in 1955) or to shock (Juliette Lewis's cornrows in 1992 or Gwyneth Paltrow's smokily done eyes in 2002), a woman can use accessories to transform herself from sex symbol to serious actress, from pauper to princess, or vice versa.

Most attendees rely on jewelry to enhance their images—and to rouse the inevitable frenzy of flash-bulbs, not to mention the watchful gaze of body-guards dispatched by Hollywood's biggest jewelers. Norma Shearer started the trend by donning multiple diamond bracelets in 1930. Since then we've seen Elizabeth Taylor's famous 69.42-carat diamond pendant, given to her by two-time husband Richard

ASHLEY JUDD WENT *flapper in 2001 with a crystal-encrusted headband and vintage jewelry by Fred Leighton. Sisters Joan Fontaine (below, left) and Olivia de Havilland dolled up in 1942 with flowers and mantillas.*

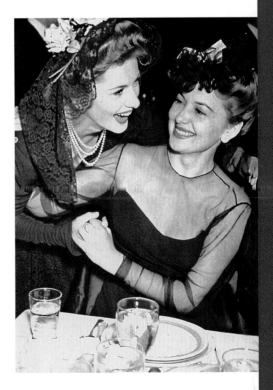

Burton and worn to the ceremony in 1970, as well as the $7 million-plus worth of diamonds Angela Bassett borrowed from Harry Winston in 1997 and Gloria Stuart's titanic $20 million blue diamond necklace of 1998. Actresses and ice have shown time and again that they're the perfect costars.

But some women dispense with the idea of the singularly spectacular sparkler and lavish attention on other details for the big night. There's Drew Barrymore, for example, who usually wears understated gowns that she pairs with such eye-popping accessories as fresh daisies (1998), a rhinestone bracelet (1999) or a green peridot necklace (2000). Or Cameron Diaz, who belted her floral Ungaro gown with a vintage Indian necklace in 2002.

Hats, as well, are a good way to Oscarize. Ali MacGraw started a run on knit caps after she wore one to the Awards in 1971. Celine Dion elicited groans with her snow-white fedora of 1999. And what about Erykah Badu's towering head wrap (made up of three feet of material) that she wore in 2000? No one will ever forget it—especially the poor soul who had to sit behind her at the ceremony.

OPRAH WINFREY WORE
*her own teardrop diamond
necklace—and why not?—in
1996 and here in 2002.*

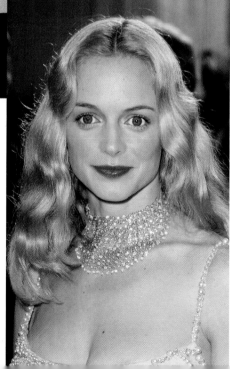

HEATHER GRAHAM
*was ready to boogie in
2000 in a Fred Leighton
bib necklace with 50 carats
of diamond briolettes.*

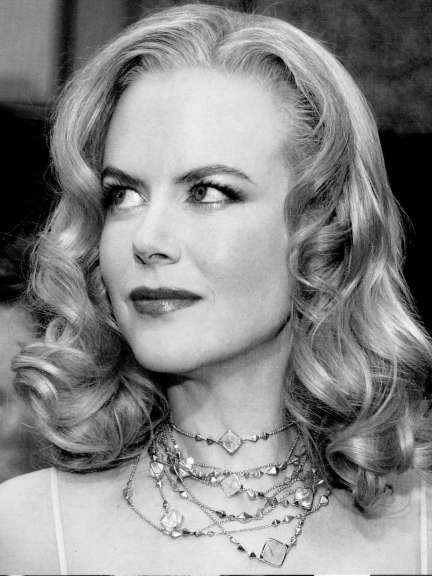

NICOLE KIDMAN
*helped design the necklace
she wore in 2002—a
$4 million, 241-carat Bulgari
made with raw diamonds.*

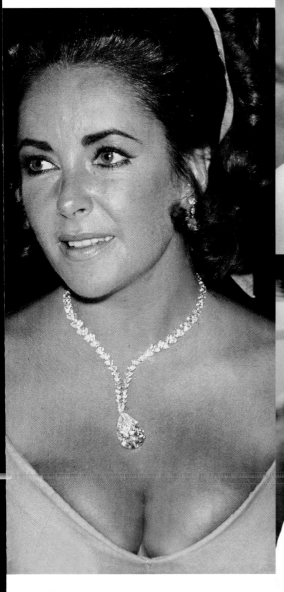

THE 69-CARAT DIAMOND LIZ TAYLOR
*wore in 1970 later sold for nearly $3 million.
In 2001, Raquel Welch glowed in about
$1 million worth of Tony Duquette emeralds.*

SHE'S KNOWN FOR HER *whimsical and original sense of style, so Drew Barrymore passed up borrowed diamonds in 1999 in favor of her own lily-shaped rhinestone bracelet.*

"IT HAD AN AFRICAN FEEL TO IT, *like the rings going up your neck,"* Angela Bassett said of the diamond Chaumet *choker she wore in 2001.* "It spoke to me."

CICELY TYSON TOPPED HER *tiered white lace gown with an elegant but fun-filled bright fuchsia floral choker in 1977.*

J E W E L R Y

A BEST SONG PERFORMER AT THE SHOW in 1997, *Celine Dion twinkled in a diamond Chanel comet necklace worth $490,000.*

SO WHO'S CRYING *now? Hilary Swank shone in 2000 in a sunburst-style necklace adorned with $250,000 worth of Asprey & Garrard diamonds.*

MADONNA'S *1998 Fred Leighton necklace, sniffed one critic, was "Camelot meets Star Wars."*

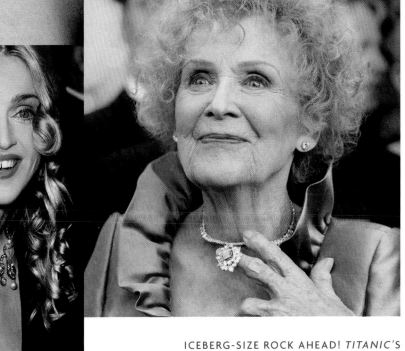

ICEBERG-SIZE ROCK AHEAD! *TITANIC'S Gloria Stuart accessorized her Escada gown in 1998 with a 15-carat, $20 million matching blue diamond pendant from Harry Winston.*

CATHERINE ZETA-JONES WENT FOR A *sleek style in 2001 with a Robert Steinken updo. Jane Fonda's 1972 shag became a much-imitated national coif craze.*

HOLD THE HAIR SPRAY! SHIRLEY MACLAINE AND DEBBIE *Reynolds modeled the big beehives of the day at the ceremony in 1964.*

H A I R

SHE'S A LONGTIME FAN OF THE RETRO LOOK, *but Winona Ryder didn't decide on her '20s-style marcelled hairdo until the morning of the Awards in 1996.*

"UNFORGIVABLE": THAT'S
what designer Randolph Duke
called Gwyneth Paltrow's 2002
choice of bruised-eye makeup.

"I REALLY LIKED
the way it looked,
and I wanted
my face out there,"
Cape Fear's
Juliette Lewis said
of her edgy 1992
cornrows.

THE BI-LEVEL BOB
Barbra Streisand wore
in 1969 was almost as
strange as her see-
through Scaasi pajama
outfit with bow and
bell-bottoms.

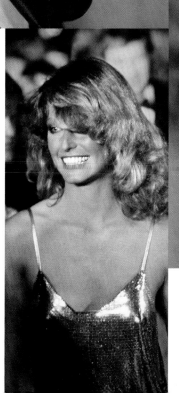

THE '70S COULDN'T
swing without the
famously cascading
hair of Farrah Fawcett,
who made an angelic
showing at the
ceremony in 1978 in
full-feathered form.

"WITH HER BALLGOWN, SHE NEEDED AN
elegant updo," hairstylist Oribe said of the Grace
Kelly-inspired bun he gave to Jennifer Lopez in 1999.

MAYBE ARETHA FRANKLIN
*sang "Funny Girl" at the show in 1969,
but she looked more like a natural
woman in a gold crown made up of
what seemed to be twigs and foliage.*

ASHLEY JUDD'S SLIT-TO-THE-THIGH
*Richard Tyler undoubtedly provoked gasps
from shocked onlookers in 1998, but she
lowered the temperature by adorning her
hair with delicate white gardenias.*

DREW BARRYMORE BALANCED
*her blonde bob with a few fresh daisies
in 1998; Bette Davis capped off her look
with a sequined gold helmet in 1955.*

A D O R N M E N T S

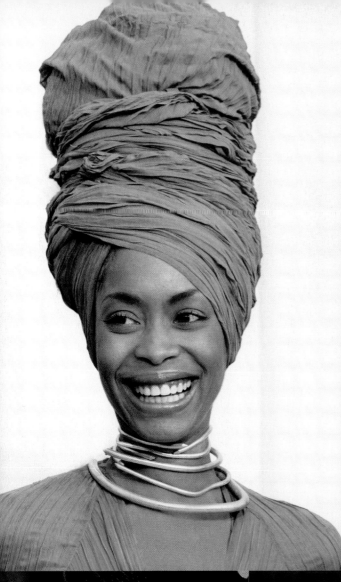

ERYKAH BADU TURNED HEADS IN 2000 WITH *this voluminous turban and spiral choker. Ali MacGraw went romantic in 1971 with a flower-decked knit cap.*

SIX FEET UNDER'S Rachel Griffiths was no stiff in 1999 with her elbow-length satin gloves and film-camera-shaped purse covered in crystals.

NATALIE WOOD TIED UP HER SNOW WHITE *ensemble in 1968 with a large girly bow in her side-swept hair. Dark, dramatic eyes didn't hurt.*

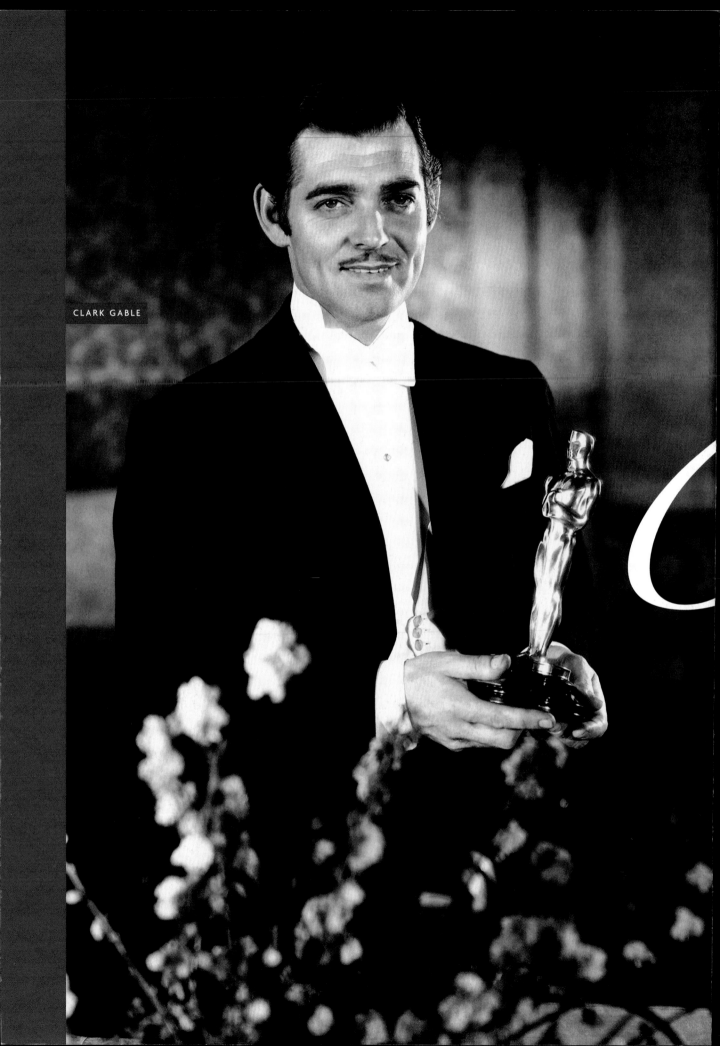

CLARK GABLE

MEN
in Black

"DON'T I LOOK LIKE I CAN STAND ON TOP OF a wedding cake?" asked 1988 presenter Tom Selleck. Indeed, he did. For decades, men's fashion statements at the Academy Awards consisted of whispery variations on the traditional dinner-dress outfit of black trousers, swallowtail coat, painfully starched shirt and white tie known as the soup-and-fish. Clark Gable wore the rig elegantly in 1935, as did Bob Hope in 1955, and the style was still going strong in 1958, when Cary Grant appeared in the full kit. By the middle of

the century, though, many men had done a quick change to the tuxedo, a less stiff and formal version of evening wear that more resembled a comfortable business suit than the formfitting cladding of a man about to plight his troth. It became a style that has had legs for decades. Marlon Brando wore one in 1955, Robert Redford in 1981 and presenter General Colin Powell in 1999.

Whether in swallowtail or tux, men rarely broke the mold. Adding a white silk scarf for the walk into the auditorium was about as far off center as a fella would go. Most seemed to agree with actor Edward Norton, who said, "The real key to style is having a girl on your arm who attracts all the attention."

A few guys, though, broke ranks. Frank Sinatra caused a stir in 1954 with a shiny silk tux, a noticeable departure from matte black. But then Sinatra always did it his way—and did it with an attitude.

Attitudes were knocked for a loop in the 1960s. The sexual revolution was gathering steam, and baby, male plumage spread its feathers on the Academy stage. Sammy Davis Jr. sported a velvet Nehru jacket and love beads in 1968. Two years later, Dennis Hopper wore a cowboy hat. For many, it was a signal that restraint was history. Others were irked. "Any man who insists on wearing his cowboy hat to the Academy Awards," growled Henry Fonda, "ought to be spanked."

In the decades since, however, it's been hats off to the fashion-forward. Men have loosened their ties—and in some cases dispensed with them completely. Sylvester Stallone proudly sported an open-collared tuxedo shirt, and Jack Nicholson once breezed into the ceremony wearing a Hawaiian shirt under his tux.

By the 1990s, self-expression had become exotic. Daniel Day-Lewis dressed in an Edwardian-style frock coat, while 2001 presenter Tom Cruise wore a modified business suit by Timothy Everest and an open-collared blue shirt. There have been crazes, too. Regis Philbin's monochromatic shirt-and-tie combinations for TV's *Who Wants to Be a Millionaire* resulted in a spate of black-on-black combinations that dulled the red carpet.

Through it all, the classics endure. When Tom Hanks appeared in 1995 in a banded shirt collar, host David Letterman joked, "Would it kill you to have worn a tie?" Whatever a star's answer to that question, getting ready for Oscar night is a no-sweat exercise for most men. Kurt Russell's routine is typical. "Grab the tux out of the closet," he says, "take a shower and throw it on."

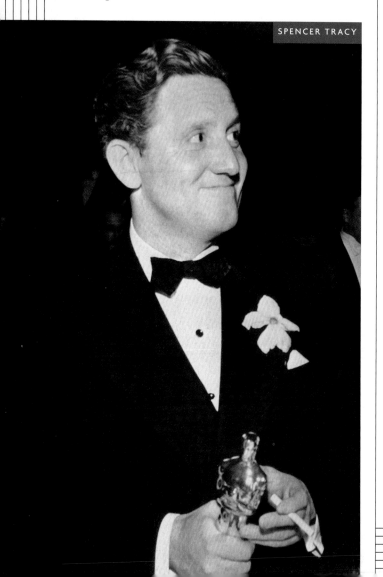

SPENCER TRACY

DAMON *and* AFFLECK *celebrated their 1998 shared Best Screenplay awards in traditional tuxes. (Affleck blamed pals for stealing his cummerbund.)* TRACY *added panache in 1939 with a flower and hanky.*

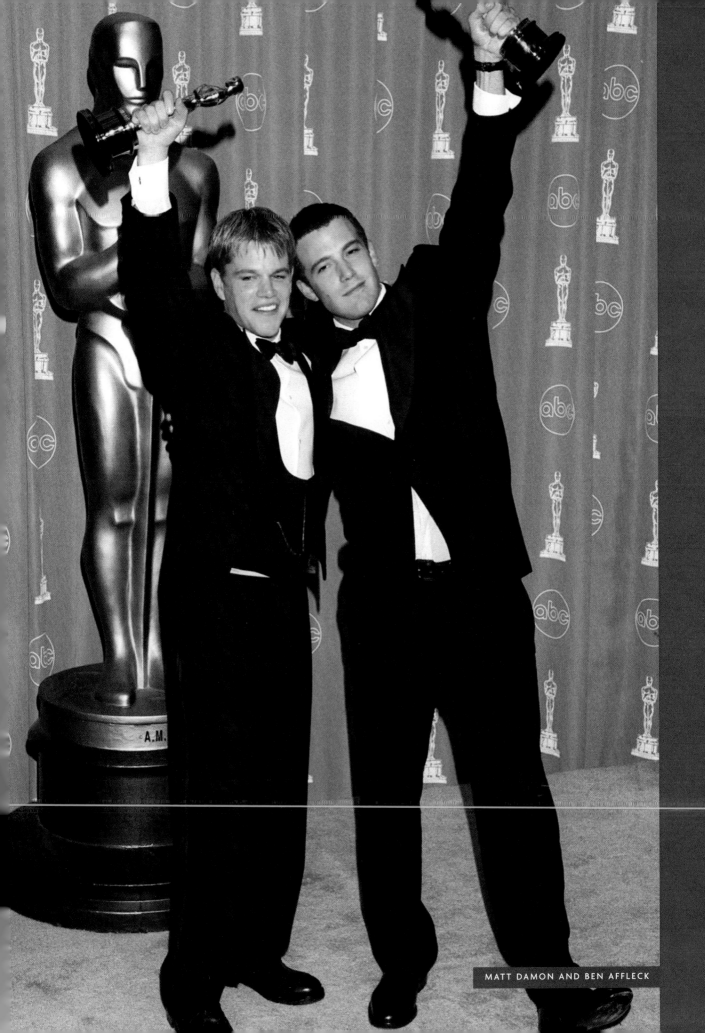

MATT DAMON AND BEN AFFLECK

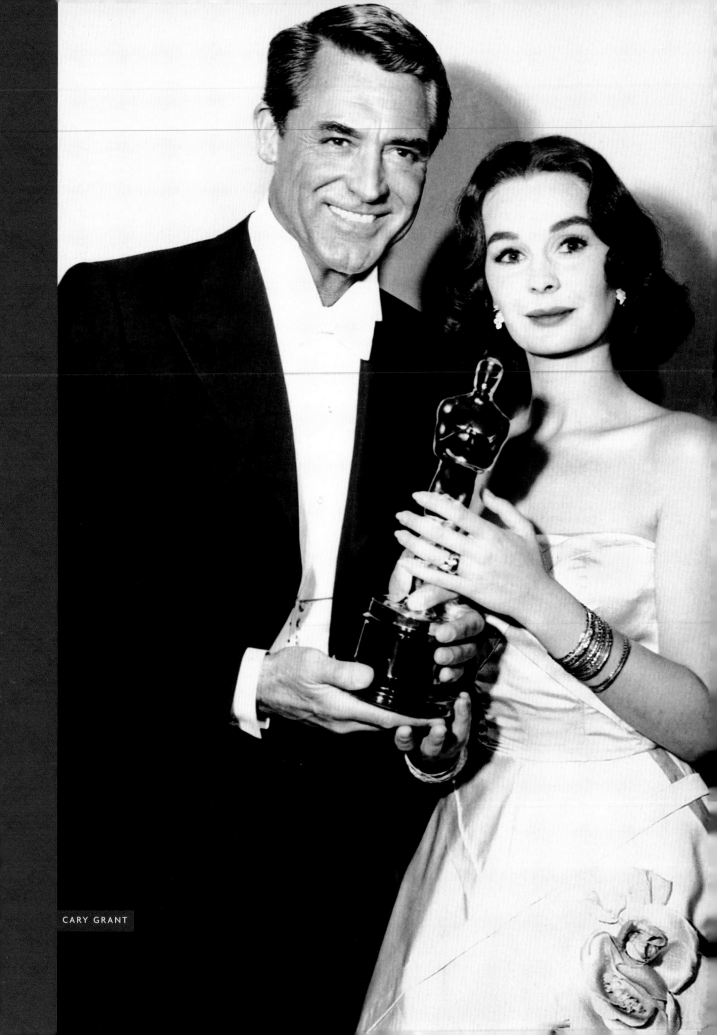

CARY GRANT

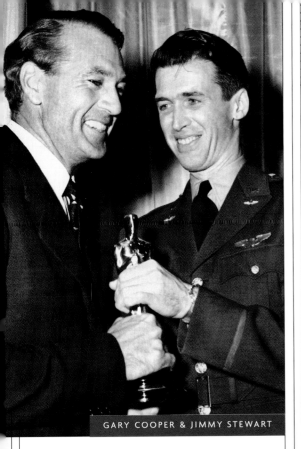

GARY COOPER & JIMMY STEWART

There was no charade at the Awards in 1958, where GRANT (with Jean Simmons) was the smoothest standout in full evening dress. No wonder he once quipped, "Everyone wants to be Cary Grant. Even I want to be Cary Grant." Honoring the war effort after Pearl Harbor, Oscar dressed down in 1942. STEWART was right in step in his Army Air Corps second lieutenant's uniform when he gave an Oscar to Sergeant York's business-suited COOPER.

"For me, a tuxedo is a way of life," SINATRA once said. In 1954 (with Donna Reed) the From Here to Eternity winner made a smooth lifestyle shift from matte-finished tradition with a shiny silk tuxedo.

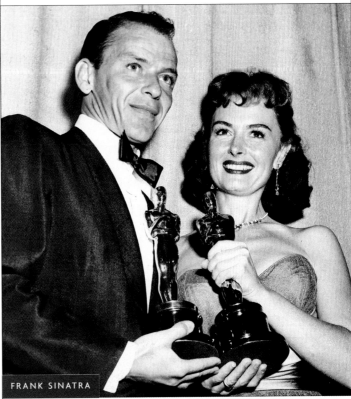

FRANK SINATRA

The yin and yang of time-honored Awards wear: Staging a mock tussle over the statuette in 1955, host HOPE wore white tie and tails, while Best Actor BRANDO chose a more modern tuxedo.

MARLON BRANDO & BOB HOPE

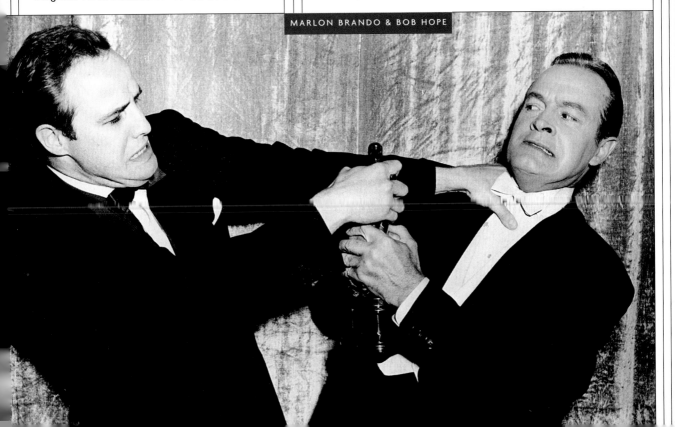

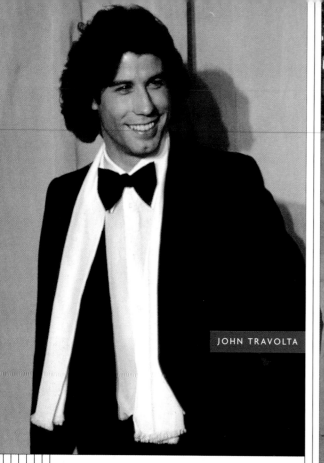

JOHN TRAVOLTA

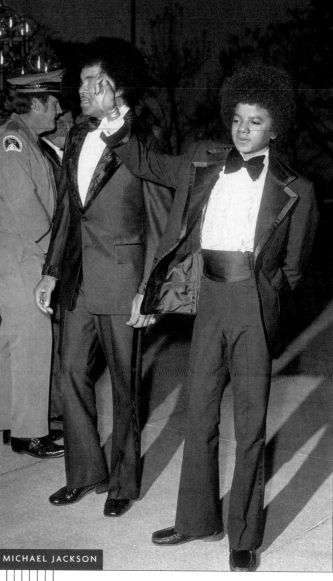

MICHAEL JACKSON

Oscar elders started feeling Saturday-night fever in the '70s, as individualists discoed away from the same old thing. TRAVOLTA updated Fred Astaire with a dashing white silk scarf in 1978. Best Song winner Hayes played it funka-delic in '72 with blue velvet and white faux fur.

ISAAC HAYES

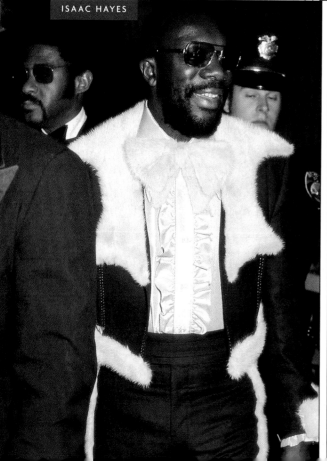

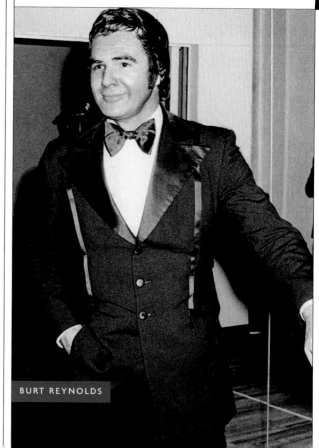

BURT REYNOLDS

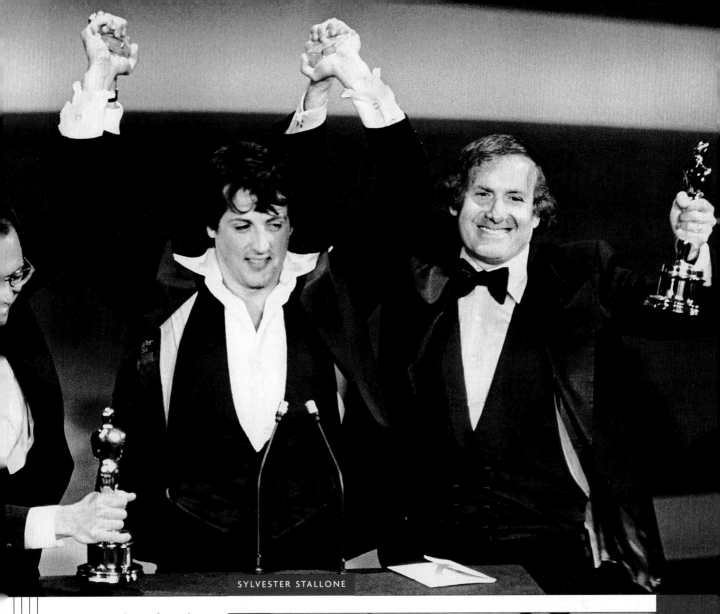

SYLVESTER STALLONE

JACKSON, *who performed a nominated song in '73, supplemented his conventional tux with a ruffled shirt, an oversize bow tie and his original nose.* Smokey and the Bandit's REYNOLDS *barely got away with his oddly constructed jacket in '74. Violating a sacred Oscar commandment in '77, Stallone (accepting the Best Picture award with Rocky producers) shocked traditionalists by going boldly open-necked and showing off his chest.* One Flew Over the Cuckoo's Nest's *Best Actor* NICHOLSON *(in '76 with Anjelica Huston) took standard formalwear to a cool new altitude with a black beret, aviator shades and Hollywood's best smirk.*

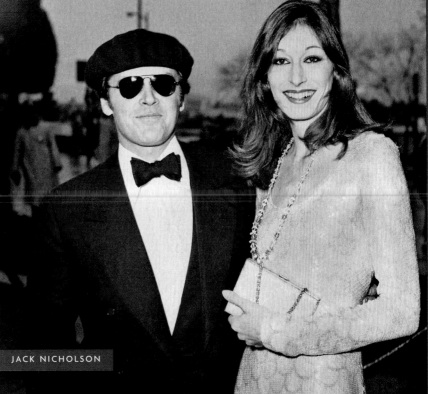

JACK NICHOLSON

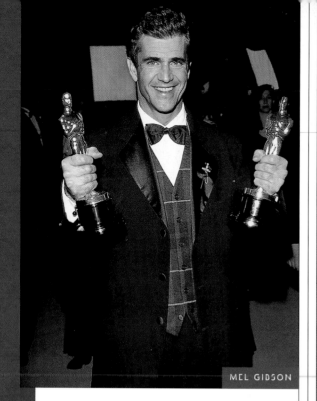

MEL GIBSON

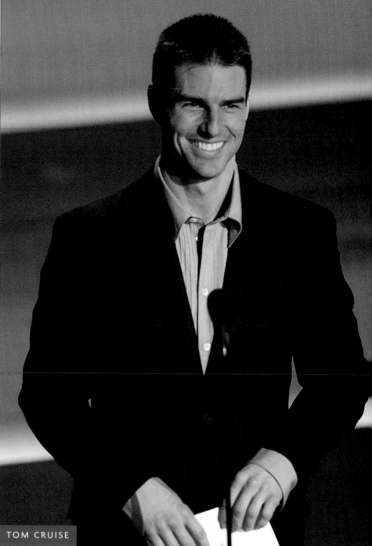

TOM CRUISE

With the exception of 2001 presenter CRUISE (clad for casual Friday in a Timothy Everest outfit), the boys of Oscar have lately gone back to class—with some vivid variations. GIBSON was all tartaned up in Armani at his '96 Braveheart double coup, WILLIAMS joked that his '98 duster was from the "Armani Amish collection," and Gladiator CROWE looked ready to rumble with a whiplash tie and aggressive hair.

LEE did the very right thing in 1990 by accessorizing his Sabato Russo jacket with a Kente cloth scarf from Kenya and a flat-brimmed hat, while WASHINGTON (with wife Pauletta Pearson) commanded the 1993 red carpet in Armani's satin-lapeled, double-breasted evening jacket and custom-made ascot.

ROBIN WILLIAMS

RUSSELL CROWE

SPIKE LEE

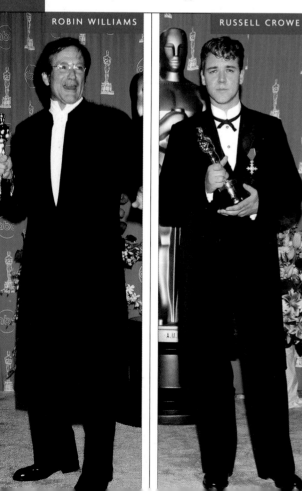

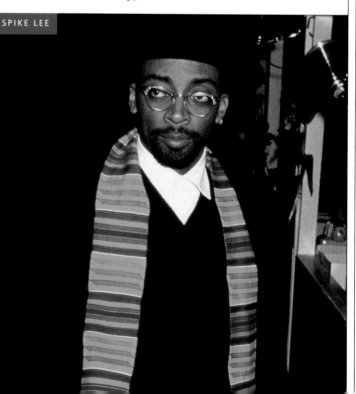

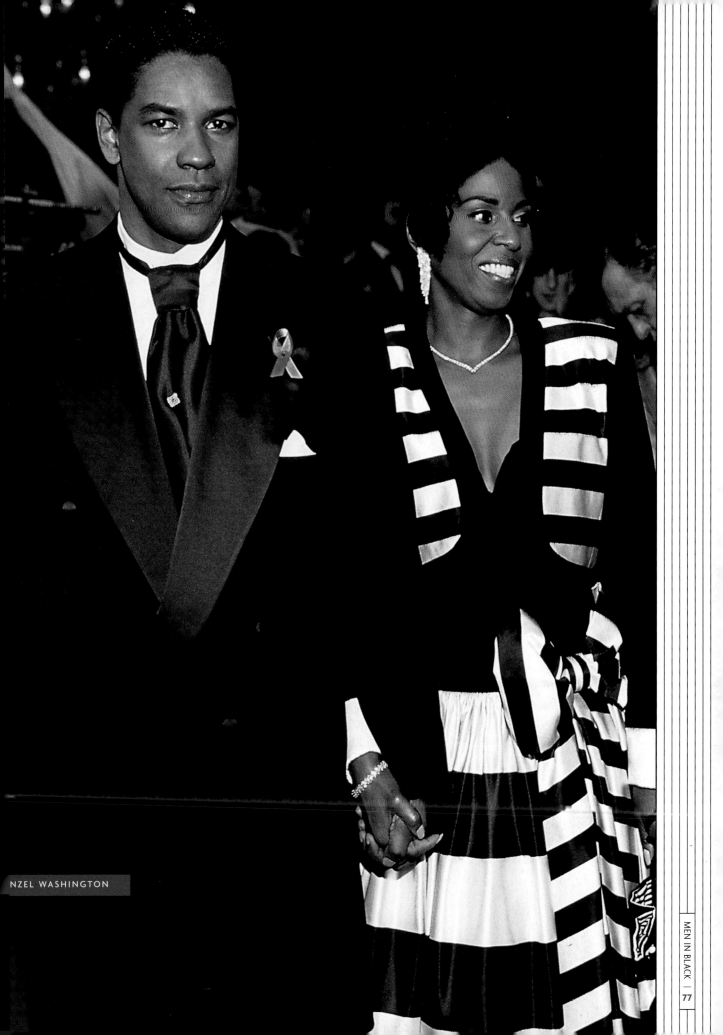

NZEL WASHINGTON

FROM *Here* TO ETERNITY

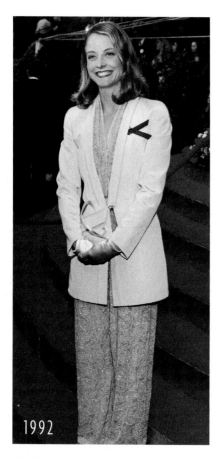

1992: *A soldier in the Armani army, Jodie Foster was calmly classic in the designer's grosgrain jacket and pink beaded pantsuit. 1971: Goldie Hawn's blossoming Oscar slip dress had many admirers, including her daughter Kate Hudson, who borrowed it to wear to a 1997 tribute to her mom in New York City.*

WHAT WILL SHE BE WEARING THIS TIME? HOW CAN she top last year? Hollywood loves sequels, which is why some stars keep coming back to make Oscar fashion statements. Whether they glam up or dress down, through marriages and motherhood, loves and losses, bad hair days and great dress nights, their return engagements keep us glued to the screen. They don't automatically go to the head of the class, though. Sometimes they hit stylish high notes and sometimes miss by a mile (see our ratings), but they never fail to cause a stir.

Among red-carpet repeaters are a who's who of old Hollywood and a sassy bunch of relative newcomers. Since 1949, Elizabeth Taylor has attended at least 15 shows, swathed in the likes of Valentino, Nolan Miller, Edith Head and Halston.

Goldie Hawn, an attendee since 1971, has found what works for her—a snug and classic column dress, but one with enough give for "movement and giddiness," according to her frequent stylist Jane Ross.

Since she first showed up in 1974, Jodie Foster has evolved from kid to class. The 14-year-old *Taxi Driver* Best Supporting Actress nominee, who would later say, "I don't give a hang about fashion," was clad in a flowery schoolgirl jumper in 1977. But by 1989, when she received an Oscar for *The Accused* in a knock-'em-dead strapless number, the script had changed. Since 1990, she has been beautifully draped by Giorgio Armani, who said

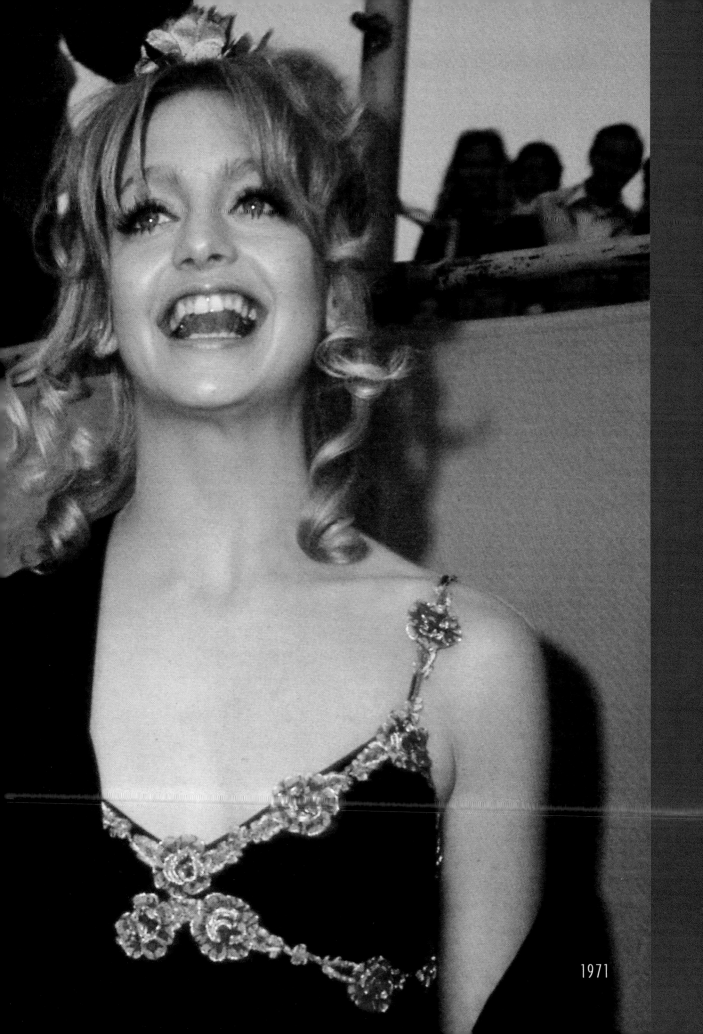

1971

that the long-sleeve beaded sheath the *Nell* nominee wore in 1995 is "one of our all-time favorites."

For others, though, serial Oscar appearances require a lot of energy to get the right style in the right color at the right point in the current fashion arc. Susan Sarandon, who appeared on the show for the first time in 1976, almost stayed home in 1998, suffering from gown burnout. "I didn't know whether I could deal with the hassle of finding another dress," she said. (She did: a sexy spaghetti-strapped black velvet Dolce & Gabbana sheath.)

And finally, of course, there's Cher, she of the provocative netting, Mohawk hairpieces and goth glam. Kind of an Oscar show all by herself, she never fails to delight and shock. Cher may be out there, but she spoke for all red-carpet recidivists in 1986, when she told her co-conspirator, designer Bob Mackie, to make something that would "let them see that everything still looks good."

"Love it or hate it," says fashion commentator Melissa Rivers, "Cher wears what she damn well wants." 1998: She took a fashion licking for her waffle-cone chapeau: D- 2000: Good Goth! Going medieval with a jeweled cross: B+ 1984: She took the plunge but barely made a splash: C 1988: The silk netting with antique bugle beads, by main man Bob Mackie, brought down the house: A

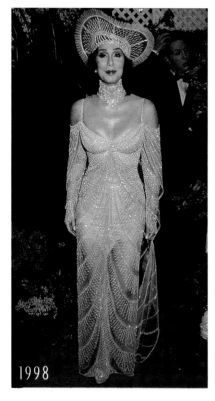

1998

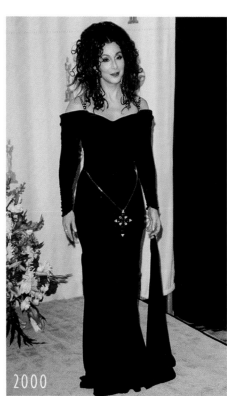

2000

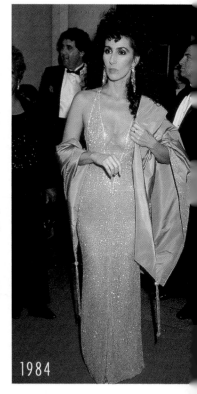

1984

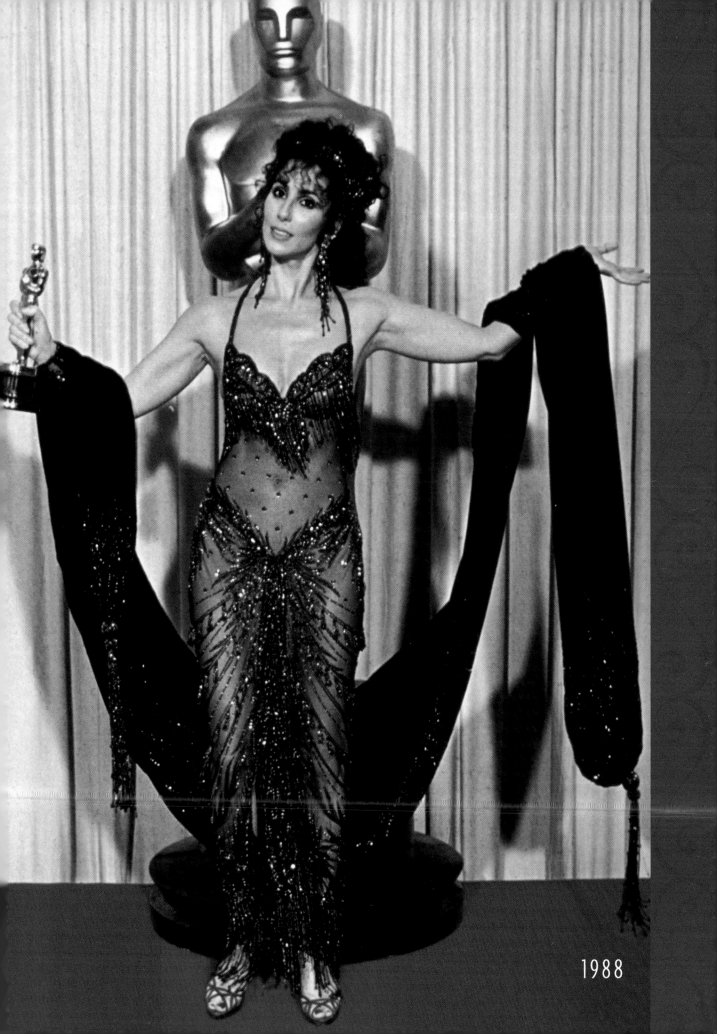

1988

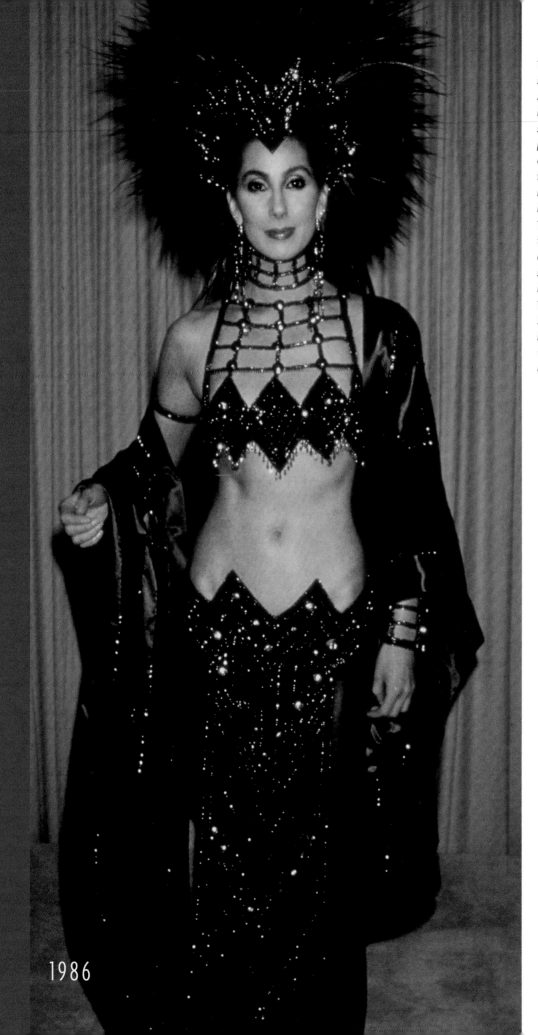

1986

1986: "As you can
see, I did receive my
Academy booklet on
how to dress like a
serious actress," the
presenter said of her
chorine creation
featuring a French-
rooster-feather
headpiece: A-
1985: Despite
the glitter, the
dowdy boat-neck
sheath didn't turn
back time: D
1968: Cher (with
Sonny Bono)
had flower power
with braids and
candy stripes: B

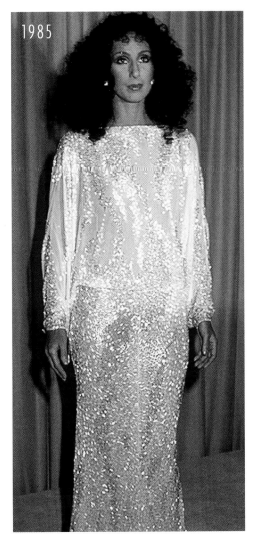

1985

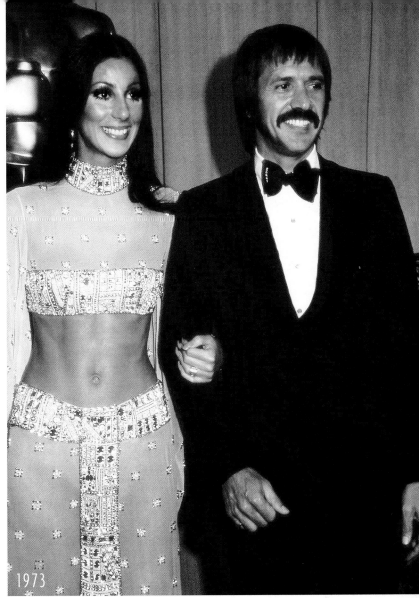

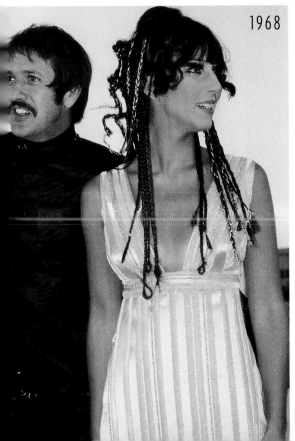

1968

1973: *Sporting Oscar's best abs—and Sonny—Cher walked like an Egyptian in gauze and gold: B-* 1974: *The splashy-print bandeau and sarong was all wrong: D* 1975: *This slit-sleeve, Empire-waisted, mustard-colored outfit shouted schmatta: D+*

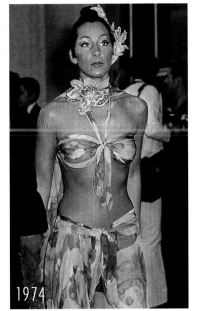

1974

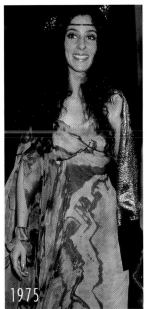

1975

1973

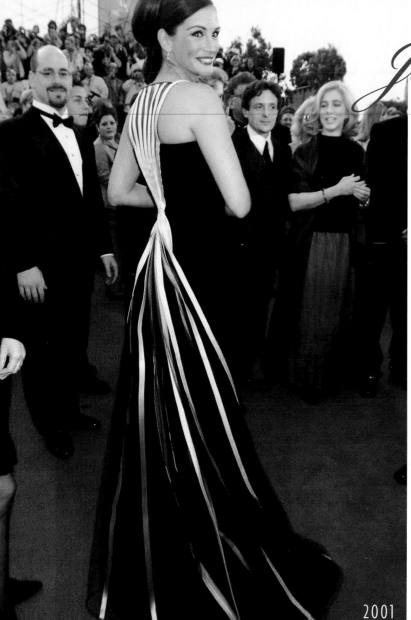

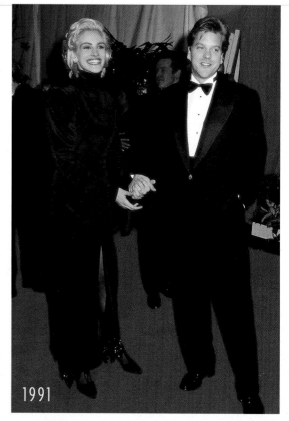

Julia Roberts

2001

1991

1990

2002

The million-watt smile is her best accessory, but America's sweetheart hasn't always set style pulses racing. 2001: Magnificent in vintage Valentino and an updo, it's no surprise the Best Actress declared, "I love the world!": A 1991: Without enough room—or vavoom—Julia (with then boyfriend Kiefer Sutherland) was almost funereal in Richard Tyler: D 1990: Marching in the Armani army, Julia went braless in a mouse-colored gown with an unfortunate gathered hem: C+ 2002: She spoiled the effect of her cutout black jersey Armani with an unstructured updo: B-

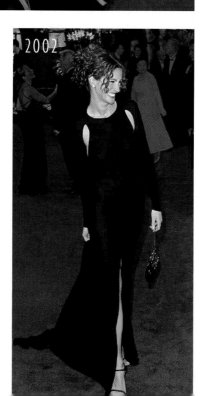

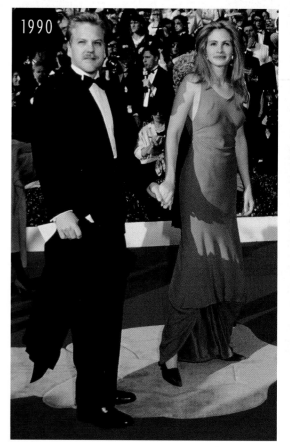

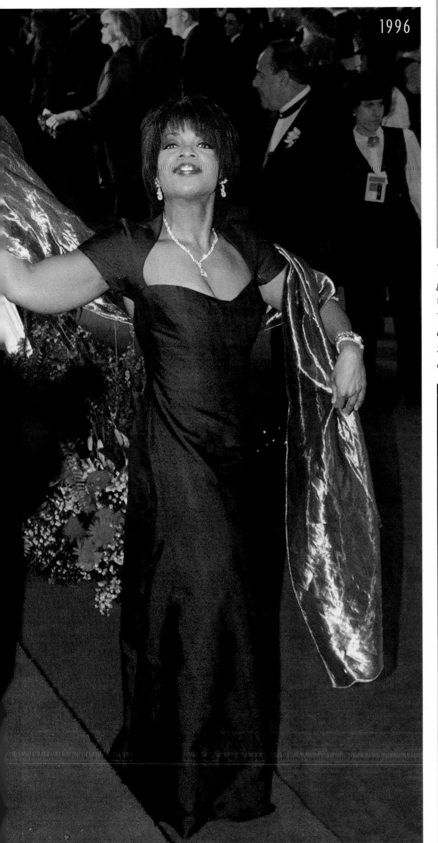

1996

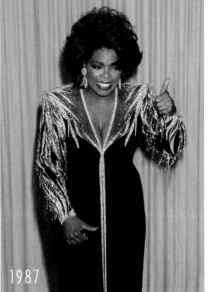

1987

The TV host does more than talk a good game. 1996: She was ready for prime time in a cap-sleeved Gianfranco Ferré: A 1987: She got low ratings for the big hair and silver-splashed Bob Mackie: C- 2002: She paired her own diamonds with a jewel of an off-the-shoulder Heidi Weisel: B+

2002

Oprah Winfrey

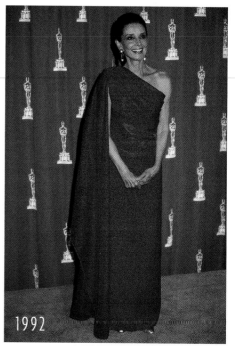

1992

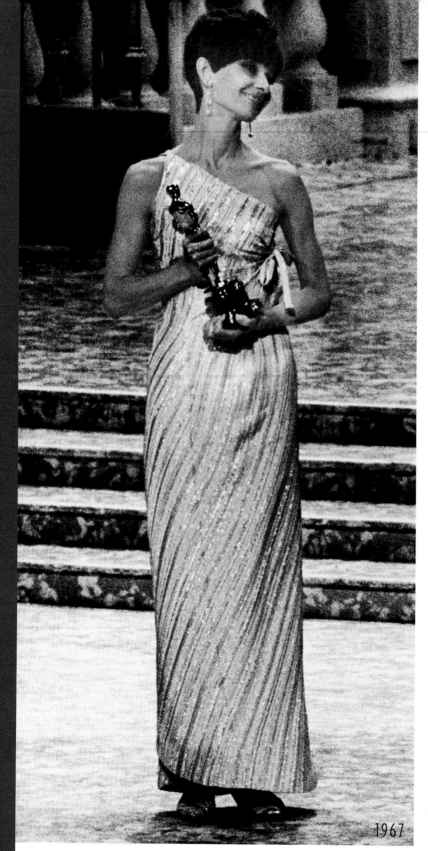

1967

"In a certain way, one can say that Hubert de Givenchy has 'created' me," Hepburn said. His style enhanced her fragile innocence and let her breathtaking beauty take center stage. 1967: Delightful in a side-tied light green gown, she proved less is more by going with simple jewelry: A 1992: Regal in red, Hepburn highlighted her long neck with bare-shouldered drama: A 1968: The bow-tied glittery vest over a long white skirt was a bit too perky, even for Audrey: B-

1968

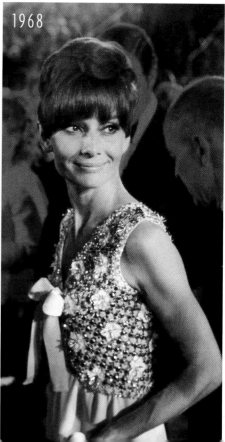

Audrey Hepburn

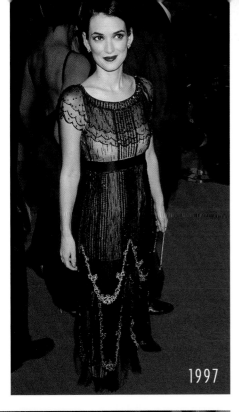

1997

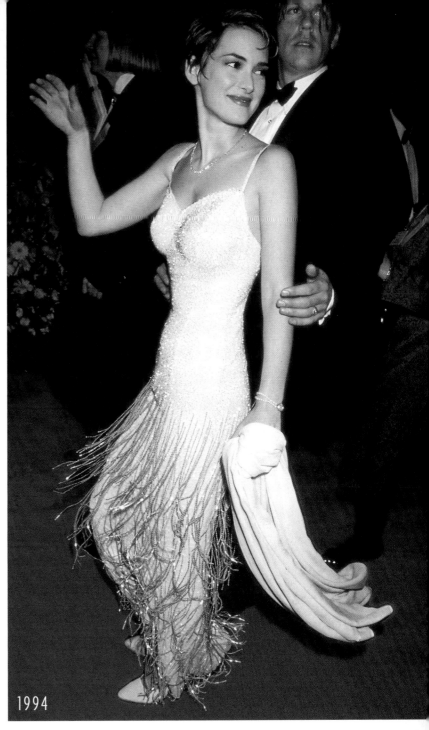

2000

1994

The petite actress has stayed on fashion's front lines by lifting from the past. 1997: One critic carped that this lace-tulle couture Chanel with a vintage feel made her look like Wednesday Addams: C+ 1994: A 1940s gown with lots of play scored with its elegant but fun beaded fringe: A- 2000: Ryder glammed up in minimalist retro Pauline Trigère, a dress that Ryder had owned for seven years and worn at three prior events: A

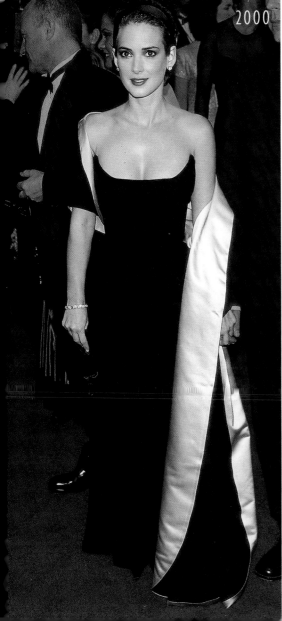

Winona Ryder

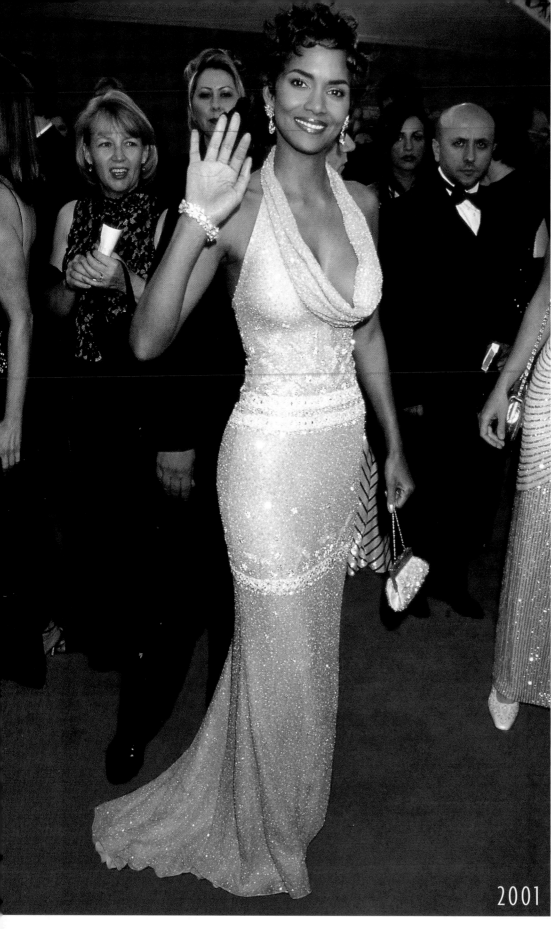

A red-carpet tastemaker, she shines with feminine elegance. *2001:* Body-conscious Berry blazed in a cowl-necked Badgley Mischka gown: A *1999:* The coat covered too much of a delicate satin-and-lace dress by Valentino: B- *1998:* "I'm not nominated, so I'm not diva-ed out," she said of her lovely lace-trimmed Vera Wang: A *1996:* Her lilac velvet-and-silk Valentino wasn't upgraded by the flowered straps: B

2001

Halle Berry

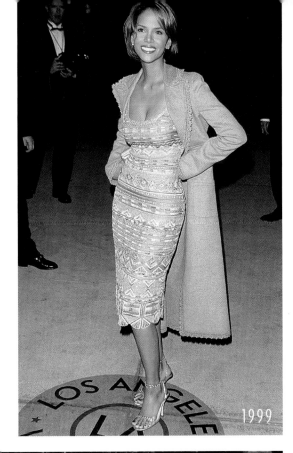

1999

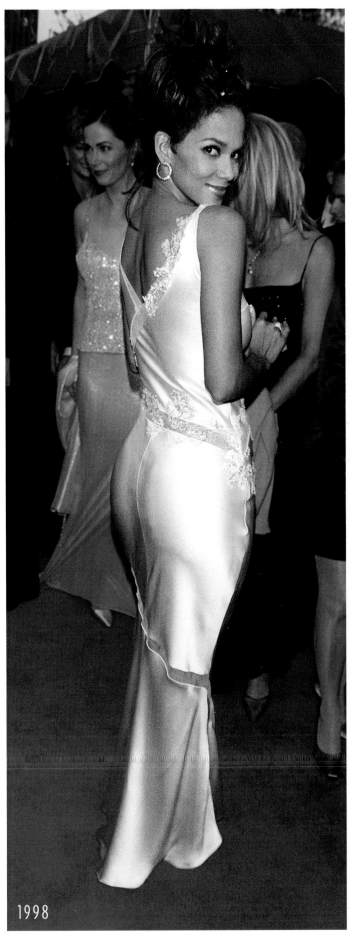

1996

1998

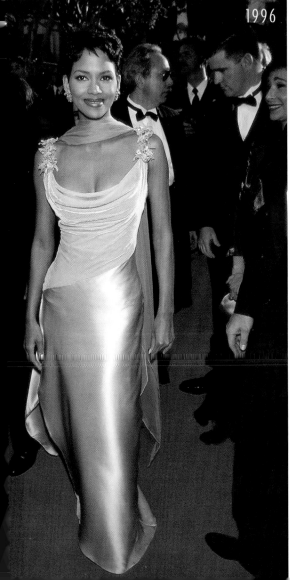

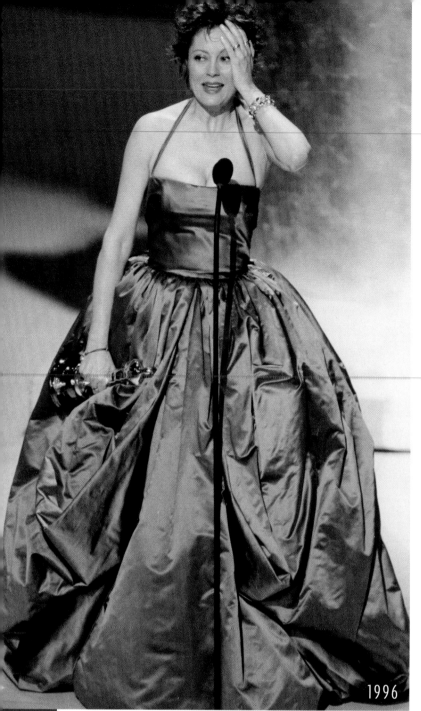

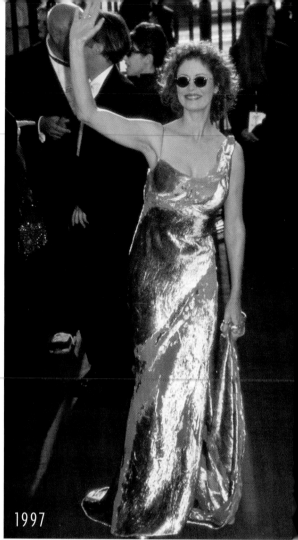

1997

1991

1996

Susan Sarandon

A drop-dead woman walking, she goes for full-throttle fashion. 1996: The Oscar winner's bronze satin Dolce & Gabbana, singled out for its glamor and elegance, is now in New York City's Metropolitan Museum of Art: A 1997: The shades didn't help this awkwardly one-shouldered gold velvet Donna Karan: C- 1991: Upswept hair held the flowing line of the crimson silk crepe Carolyne Roehm gown: B+

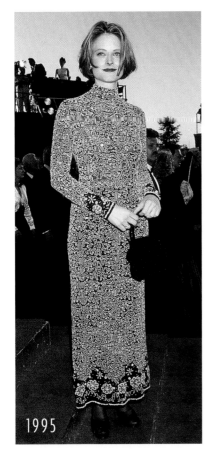

1995

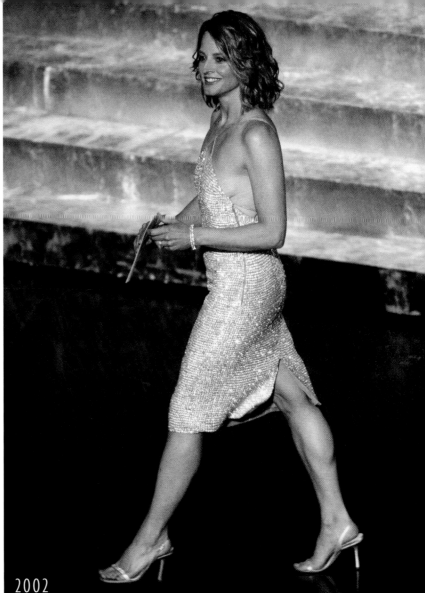

2002

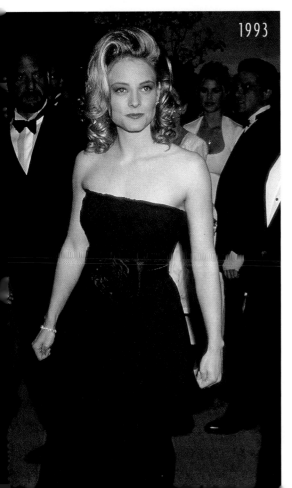

1993

Jodie Foster

Always a quick study, the Yale grad moved smoothly from adolescence to Armani. 1995: The master of Milan said that Jodie's crazy-quilt ivory-beaded sheath was "one of our all-time favorites": B 2002: Showing some leg and décolletage, she was no lamb in a shimmery, spaghetti-strapped Armani: A 1978: "I like things that are comfortable," said the schoolgirl, sloppy in a rope belt and velvet pants: D 1993: The big purple flower on her promlike strapless Armani was bloomin' awful: C

1978

Barbra Streisand

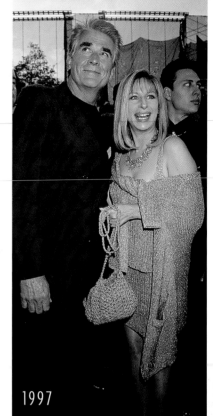

1997

Once a funny girl, she has carved out her own elaborate style. 1970: Women's Wear Daily called the Scaasi that Babs (with John Wayne) chose "a nice pink bar-mitzvah-mother dress": B 1997: With hubby-to-be James Brolin, she was over the top in Donna Karan and a busy Fabergé necklace: C+ 1992: She looked batty in this crimp-winged Patricia Lester gown and jacket: C 1969: The see-through toreador style of her Scaasi pajamas waved a red fashion flag. B-

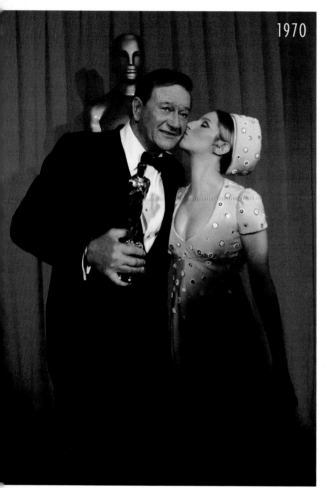

1970

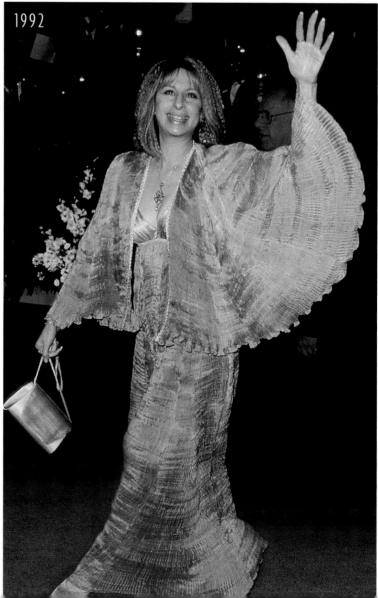

1992

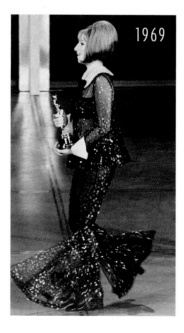

1969

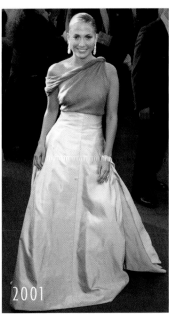

2001

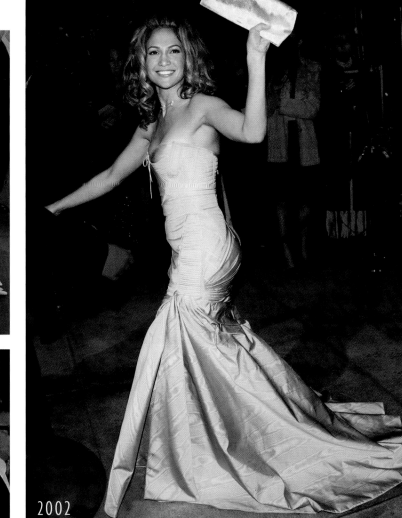

1998

2002

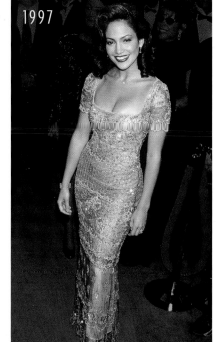

1997

Jennifer Lopez

Her fans can't wait to see what style envelope she'll push next. 2001: "I love getting dressed up," she said of her glamorous, shoulder-friendly Chanel: A 2002: She hit a new J.Low by topping a pink Versace with a big bad bouffant: C+ 1997: Her remix of old Hollywood beauty in Badgley Mischka was mostly in tune: B- 1998: She showed off her best-known asset in this Badgley Mischka: B

Elizabeth Taylor

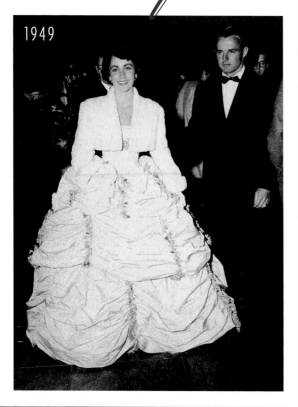

1949

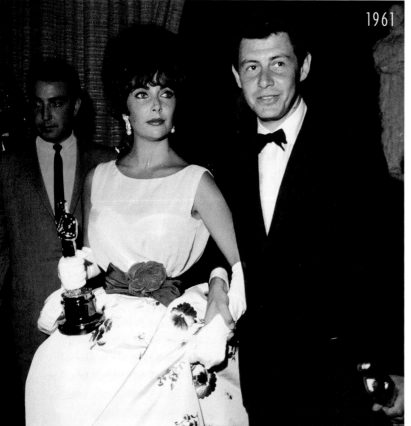

1961

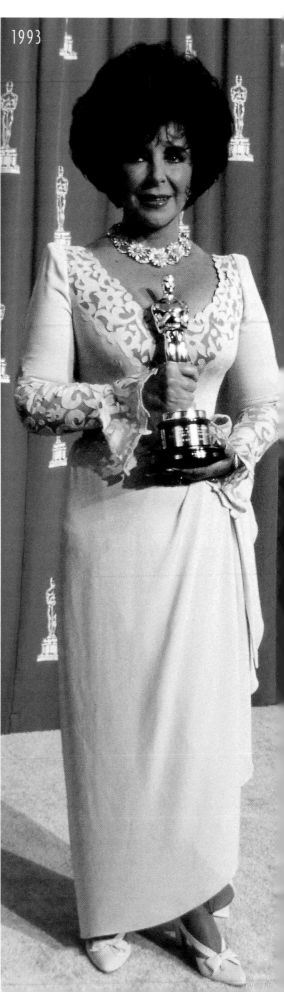

1993

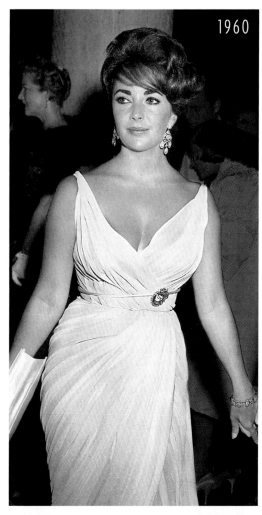

1960

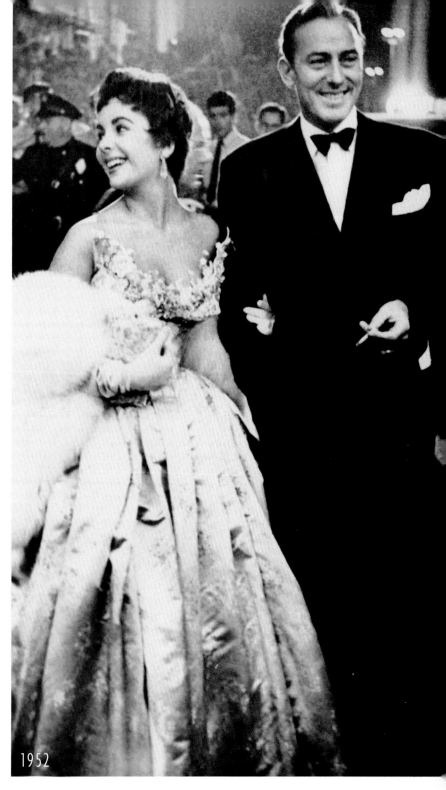

1952

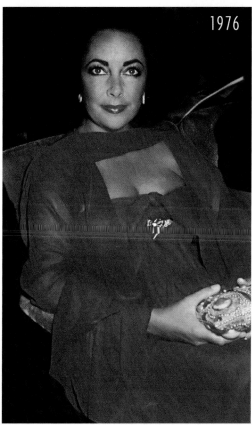

1976

What Cleopatra was to Egypt, Liz is to the Oscars. And, fittingly, she's always dolled up for envelope drama. 1949: The ingenue was wedding-cake classic in this white ballgown with decorative forget-me-nots: B 1961: The Best Actress accessorized her stunning full-skirted Dior with fourth husband Eddie Fisher: B+ 1993: The Humanitarian Oscar winner looked grandmotherly in a puffy-shouldered, long-sleeve canary-yellow Valentino: C- 1960: Taylor was hot as a cat on a tin roof in a low-cut white chiffon gown with jeweled brooch: A 1952: The newlywed (with second husband Michael Wilding) was red-carpet regal in a strapless, full-skirted satin ballgown in the popular silhouette of the time: B+ 1976: Halston, self-enchanted, christened the color of his gown "Elizabeth Taylor Red": A

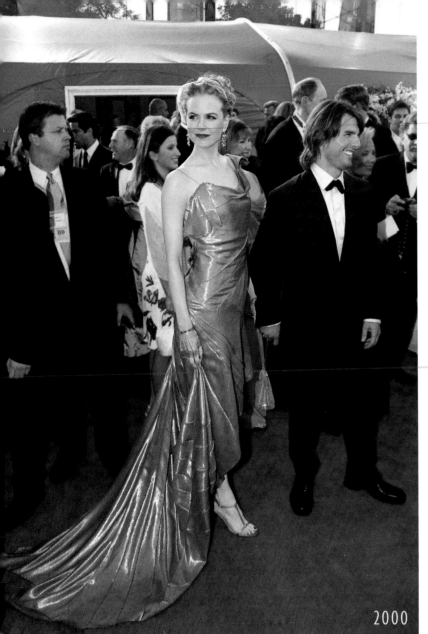

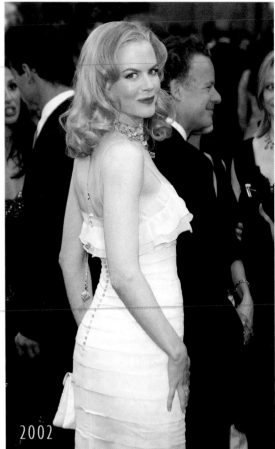

2002

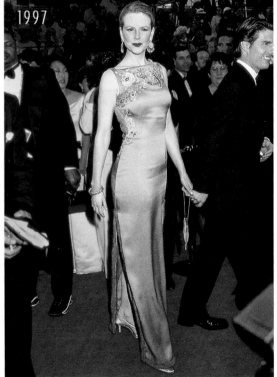

1997

1996

2000

She's a trendsetter to die for. 2000: This spun-gold design by John Galliano for Christian Dior didn't need Tom Cruise to add sparkle: B 2002: She wanted something airy after her divorce from Cruise; Chanel did the trick: A 1997: Her chartreuse cheongsam by Christian Dior was regal: A- 1996: She was one of the first to wear Prada (here with an Empire waist) to the Awards: A

Nicole Kidman

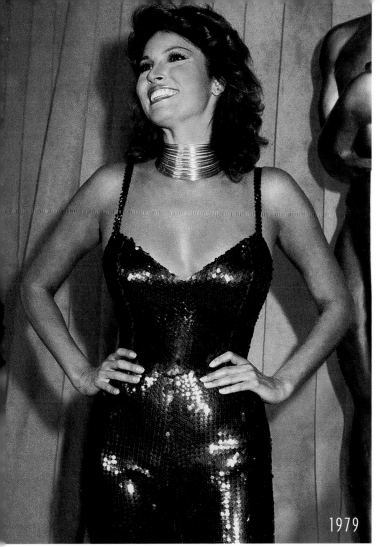

1979

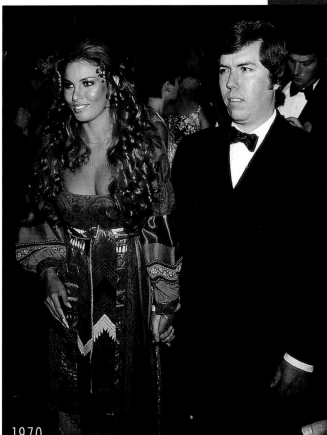

1970

Raquel Welch

The sex symbol who once said that the mind is an "erogenous zone" has given Oscar plenty to think about. 1979: Her sequined cat suit was so tight she had to lie down for the limo ride. D+ 1970: Raquel, Raquel, let down your hair! The fairy-tale getup (and then husband Patrick Curtis) couldn't save the princess: D+ 1998: This nudie lace-and-satin number didn't fit the bill—or her: D 1973: The Rita Hayworth '40s look was sleek, sexy and sophisticated: A

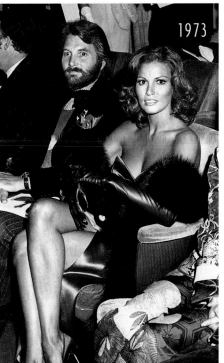

1973

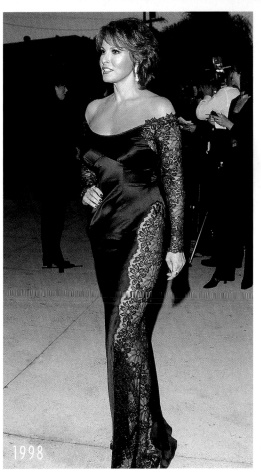

1998

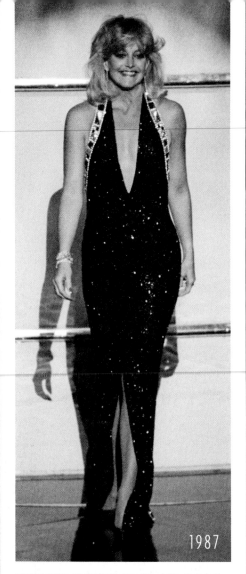

1987

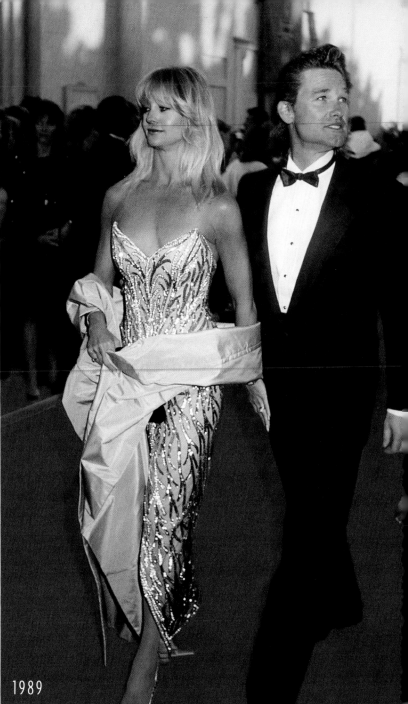

1989

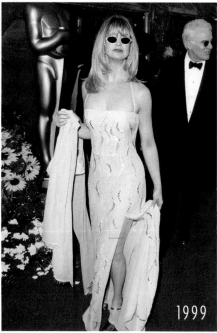

1999

Over three decades, her Oscar look has stayed suavely steady with classic column gowns. 1987: Bountiful in beads, she hit a grown-up glam note: A- 1989: Hawn (with longtime guy friend Kurt Russell) scored with her jeweled Bob Mackie but should have left the extraneous wrap at home: C 1996: Magnificent in mint, she set off her Versace with $850,000 worth of borrowed ice: A 2001: Goldie sparkled like a chandelier in an overly busy Vera Wang: D+ 1999: Did she diet to fit into her wishy-washy blue Versace? "Heavens, no," she said. "I'm a fun lover": B

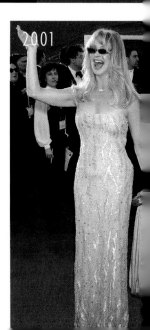

2001

Goldie Hawn

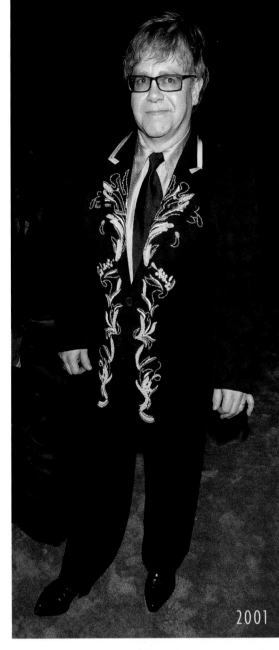

2001

Elton John

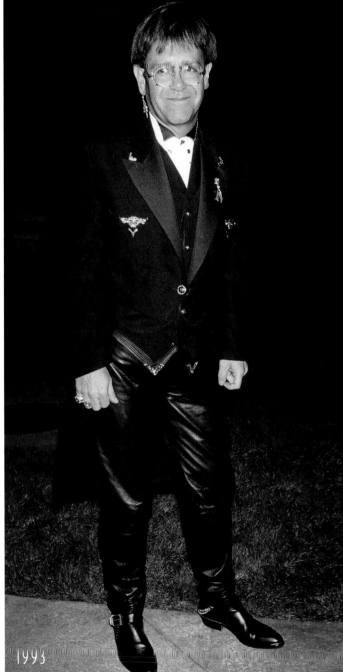

1999

1996

1993

"*If I have one addiction left in my life, it's shopping,*" *Sir Elton once said. He remains the Captain Fantastic of fashion, thanks to a giddy spirit of fun and buying sprees at the house of Versace.* 2001: *This evening suit with the circus-wagon trim missed the center ring:* C- 1993: *The Rocket Man rode a winner in leather pants and silver spurs:* A 1999: *Sad suits say so much. Way too much:* C+

GUYS *and* DOLLS

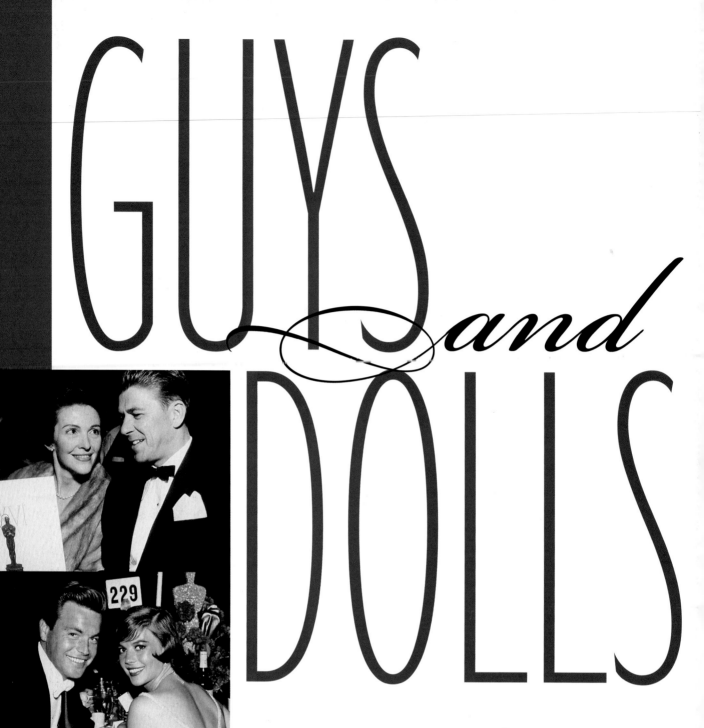

NANCY AND RONALD
Reagan looked over the program for the 26th annual Awards in 1954. Young lovers Robert Wagner and Natalie Wood struck a cute pose at their dinner table in 1960.

THE SECRET OF A SOLID RELATIONSHIP? IN HOLLYWOOD, MAYBE IT lies in two people getting dressed to the teeth and heading down the red carpet with each other. The couples who Oscar together often have a habit of staying together: Bogie and Bacall, Ron and Nancy, Kurt and Goldie, among others. The best example of the rule is power couple Paul Newman and Joanne Woodward, who deserve a lifetime achievement award all their own. They began attending the Awards together in 1958 (she accepted her Best Actress award for *The Three Faces of Eve* in a homemade gown) and have been together for more than four decades. And in an arena where style is all, flattery inspires longevity. Ryan Phillippe was on the right track when he said of wife Reese Witherspoon, "I'm with the most beautiful woman here."

NEWLYWEDS
Joanne Woodward and Paul Newman took a spin on the dance floor at the Governors Ball at the Beverly Hilton Hotel in 1958.

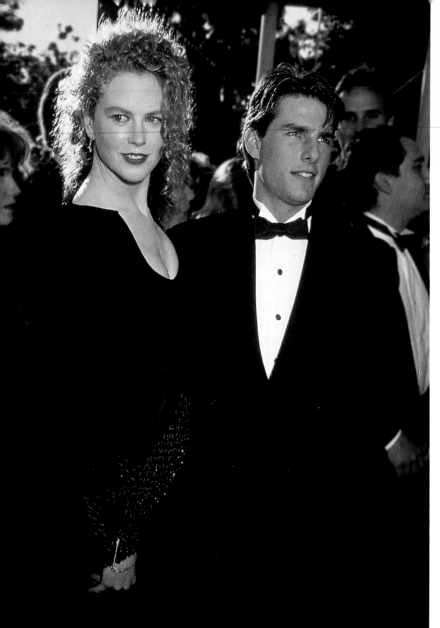

'It's not really fun. Our children are all over us and we're just basically trying to get out the door'

—ANNETTE BENING, on dressing for the Oscars with Warren Beatty

MAKING HER DEBUT AS MRS. TOM CRUISE 1N 1991, NICOLE *Kidman accidentally ripped the lining of Anjelica Huston's dress.*

"SHE GARDENS IN HER *gown all the time,"* Ellen *DeGeneres joked of Anne Heche (in Cerruti) in 1999.*

SUSAN SARANDON MADE EYES AT TIM *Robbins in 1995, despite his awful Richard Tyler suit.*

"SHE LOOKED CUTE;
he can wear anything,"
Versace said of Jada Pinkett
and Will Smith, both in the
designer's duds in 1997.

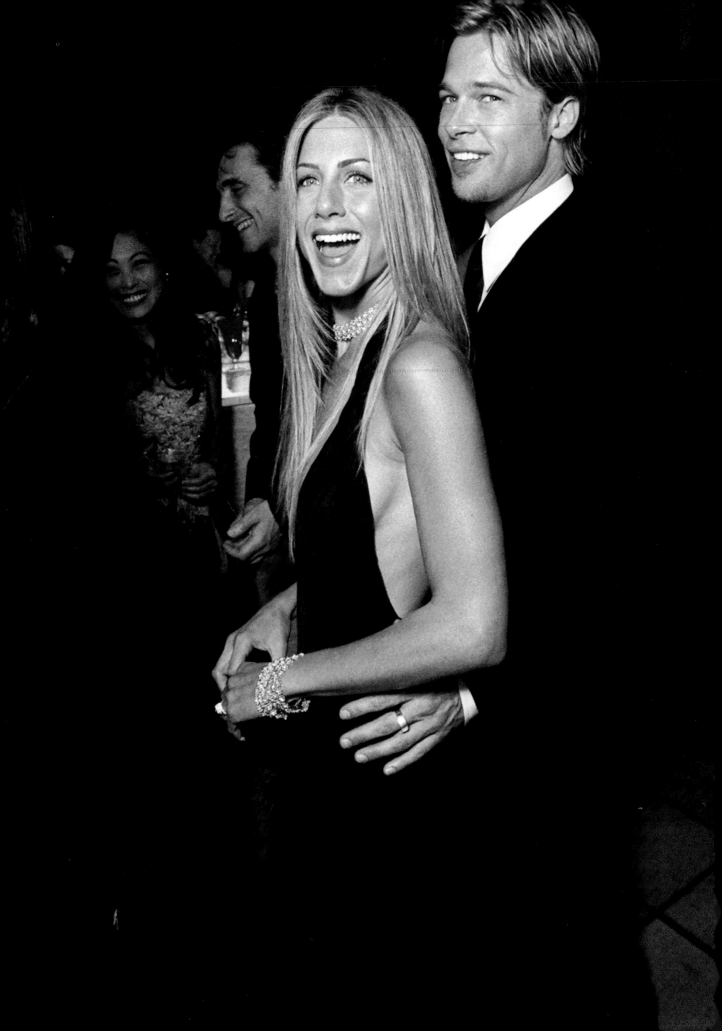

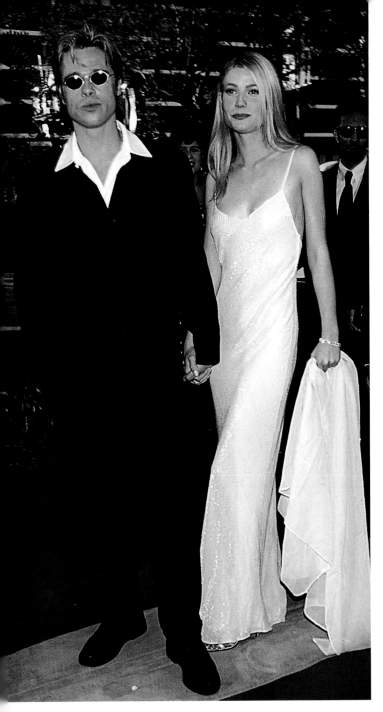

'We had our family around all day. We just hung out at home, laughed, looked at old pictures and chilled'

ERIC BENET,
on preshow activity with wife Halle Berry

CORNROWED SQUEEZE
Juliette Lewis (on the red carpet in 1992) was "like from another planet," said Pitt. "But a nice planet."

OPEN-COLLARED IN
1996, Pitt and then-girlfriend Gwyneth Paltrow (in Calvin Klein) gave other attendees something to talk about.

THE MANY PARAMOURS
of Pitt: Brad and Jennifer Aniston (in Lawrence Steele) did basic black at the 2000 Vanity Fair party.

> 'If it took three hours to get ready for the Oscars, I would take two hours and 45 minutes. Tom would take 15'
>
> —RITA WILSON, Tom Hanks's wife

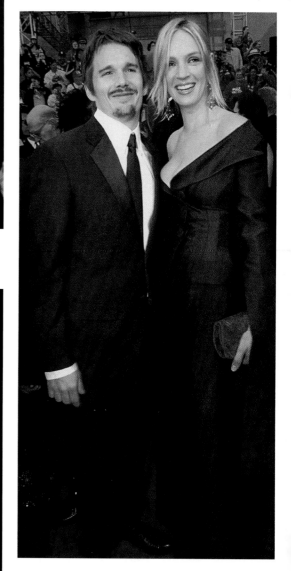

THEN-HUSBAND ALEC BALDWIN WAS A BIG HELP TO KIM *Basinger at the 1998 show. When the Escada-clad actress was named Best Supporting Actress, it was Baldwin who told her to "get up."*

ANNETTE BENING *(in Escada) and husband Warren Beatty enjoyed a quality moment together at the Governors Ball in 1999.*

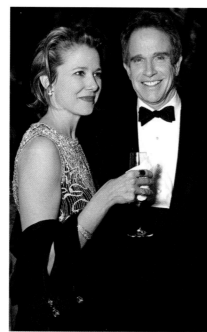

SHE'D JUST GIVEN BIRTH TO THEIR SECOND *child, but Uma Thurman (in Jean Paul Gaultier) and Ethan Hawke were ready to party in 2002.*

IN HIS 1995 BEST ACTOR
*speech, Tom Hanks said of
Rita Wilson, "I am standing
here because she has taught
me . . . just what love is."*

OSCAR'S ALL-TIME

Best

BEST ACTRESS IN 1985? BEST PICTURE IN 1939? BEST Actor in 1994? There are dozens of other books that will answer those posers. Here we're only interested in questions that really perplex the world. Like why did Charlize Theron go for a vintage look in 2000, and who designed Halle Berry's smashing 2002 gown? Why did Celine Dion proudly wear a backward tux jacket in 1999, and why, oh why, did Geena Davis show up in 1992 as a kicky cancan girl?

Some celebrities accentuate their assets, while others go wacky and tacky. The look can be glamor gal, minimalist, skin city, bombshell or bohemian. But no one genre guarantees that a star will be lauded as a style superwoman or branded a fashion disaster area.

The difference between being a leader and a loser is in the charisma of the clothes and how they're worn. An

actress can slip from best to dreadful from one year to the next. Davis, for one, has been on both sides of the fashion divide. The red carpet, after all, is a global style stage, and Hollywood's high priestesses do whatever it takes to wow the crowd—even if it means going too far. They'd all echo what Best Supporting Actress Marcia Gay Harden said in 2001: "The Oscars may only come along once in a lifetime, and I just wanted to feel and look like a movie star."

CHARLIZE THERON *(left) received raves for this daring Vera Wang in 2000. In 1992,* GEENA DAVIS *(right) flopped in a fluffy satin number by Ruth Myers and Bill Hargate.*

Worst
DRESSED

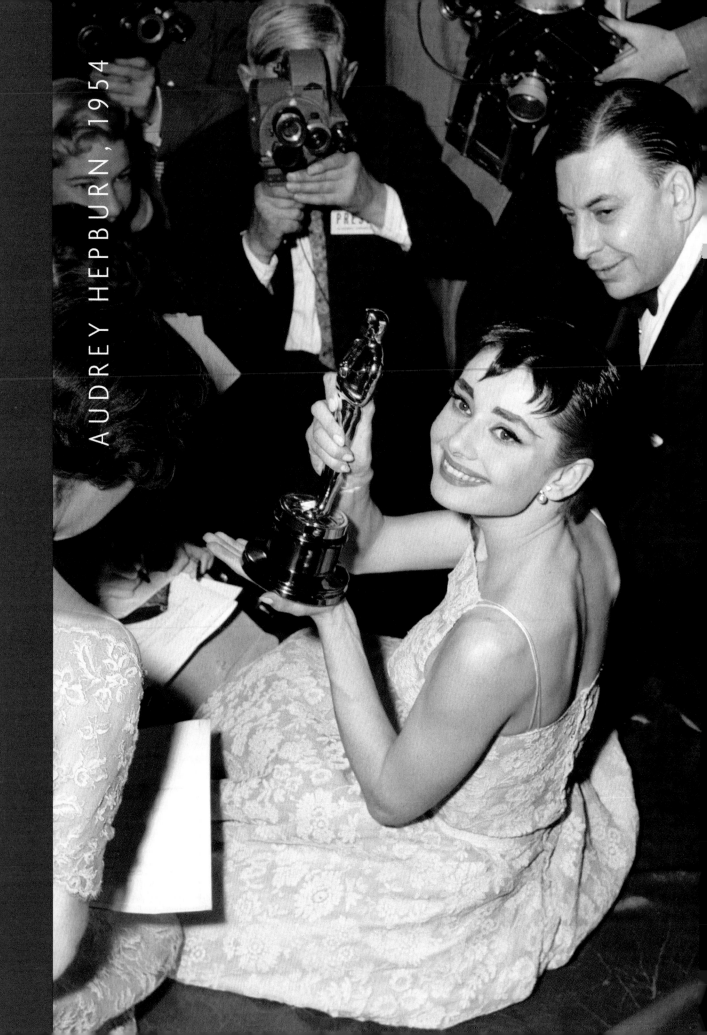

AUDREY HEPBURN, 1954

Best Dressed

Best Actress HEPBURN *was perfection in a belted floral lace dress with bateau neckline by Givenchy.* KELLY *was regal in an Edith Head ballgown and shoulder wrap.*

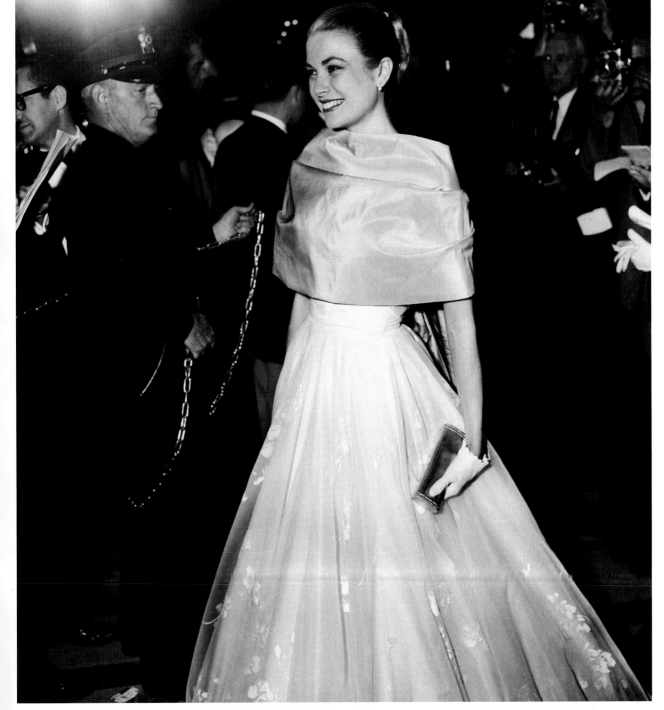

GRACE KELLY, 1956

"The material alone cost $4,000," said designer Edith Head of Oscar winner KELLY's blue silk gown with spaghetti straps, accessorized with 16-button opera gloves. About a year after husband Mike Todd's death, TAYLOR caused jaw-wagging with her sexy black chiffon gown and her date—soon-to-be next husband Eddie Fisher. ANN-MARGRET turned heads in a body-hugging yellow gown by Don Feld with a halter top and a Kelly flourish (the gloves).

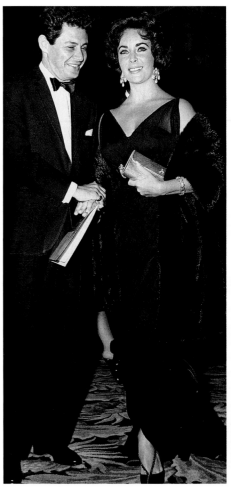

ELIZABETH TAYLOR, 1959

Best

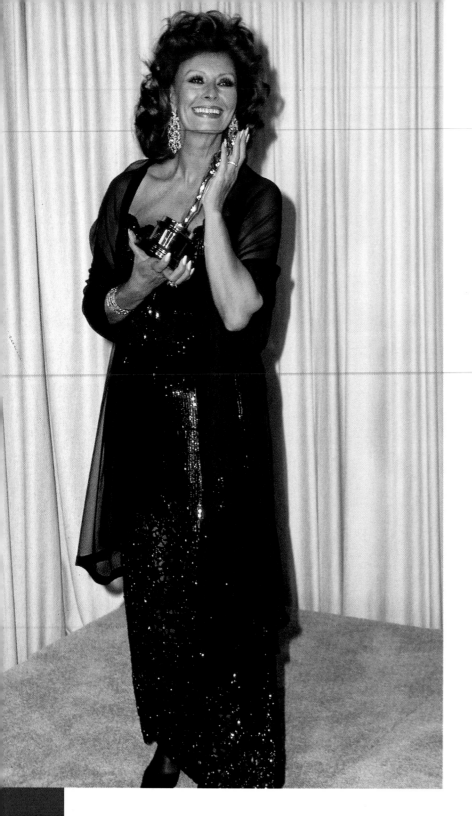

LOREN *stayed loyal to European design in her black Valentino.* BENING *wore a beaded costume from Bugsy, saving money but hitting the jackpot.* TANDY's *Armani jacket-and-skirt combo was a winner.* "If you're ever going to dress, this is the night to do it," *said* WINFREY, *in a silk organza Gianfranco Ferré.*

SOPHIA LOREN, 1991

Best

JESSICA TANDY, 1990

OPRAH
WINFREY,
1995

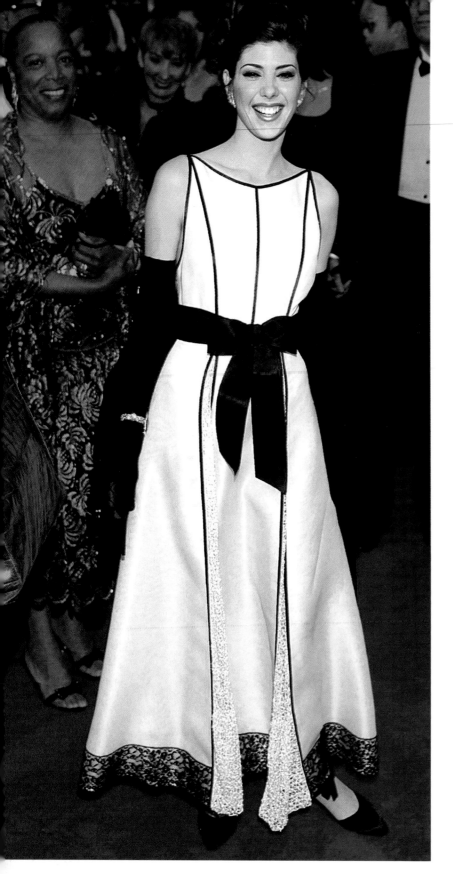

So the movie critics kvetched about TOMEI's *Best Supporting Actress* win for *My Cousin Vinny. Tough.* The fashion crowd fell in love with her couture Chanel gown in white silk organza with black piping. CLOSE *was fatally attractive in a full-length, long-sleeve silver Armani with high neckline.*

GLENN CLOSE, 1994

UMA THURMAN, 1995

Best

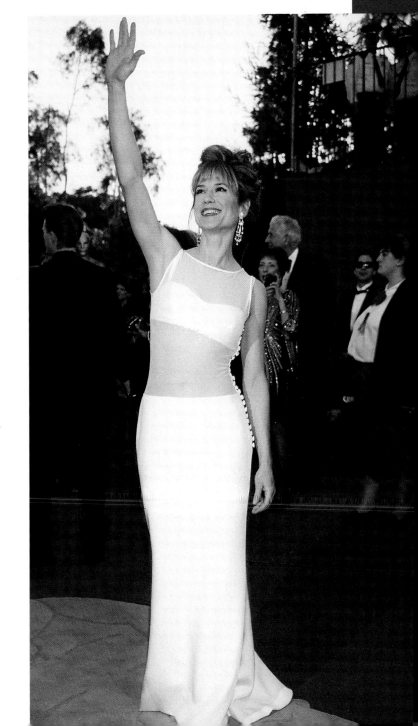

HOLLY HUNTER, 1995

THURMAN *sparked a fashion revolution when she wore this lavender Prada gown with beaded chiffon overlay, introducing the design house to the world and a sophisticated restraint to Oscar fashion. Saying she wanted something "fun and risqué,"* HUNTER *wore a sheer white Vera Wang tank dress with built-in sequined bra.*

Worst Dressed

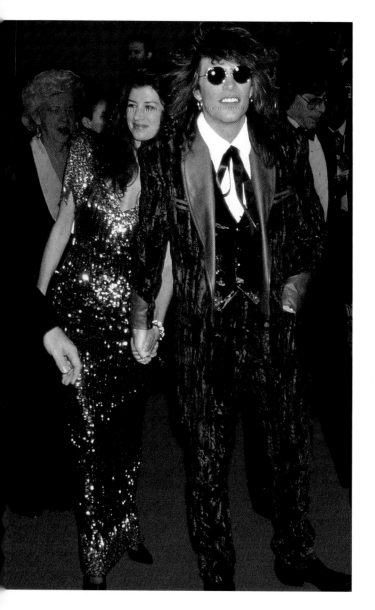

Rocker BON JOVI (with wife Dorothea) went for the psychedelic Wyatt Earp look. MINNELLI was bowed over in a crimson cape. It's a gown! It's pants! No, said GOLDBERG. "It is Hollywood."

LIZA MINNELLI, 1988

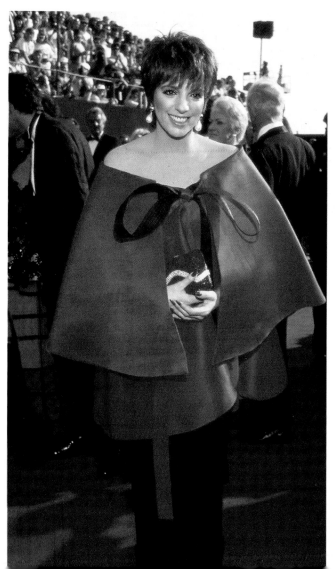

JON BON JOVI, 1991

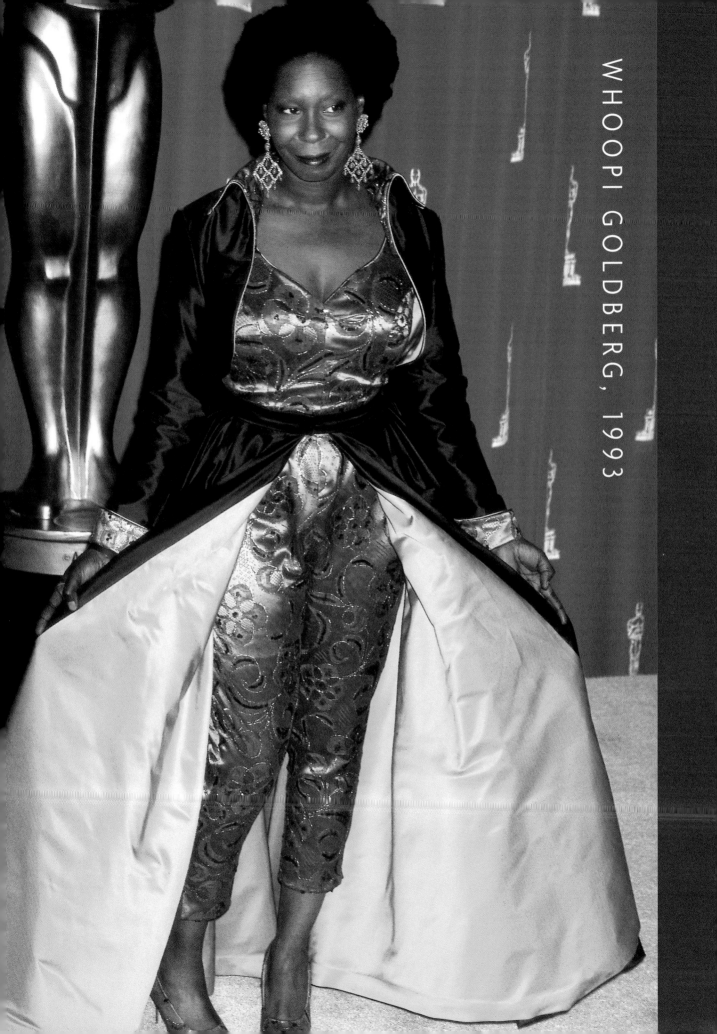

WHOOPI GOLDBERG, 1993

LILY TOMLIN, 1976

Worst

Some think TOMLIN's cartoonish tiara was an Oscar put-on. REYNOLDS channeled a frontier saloonkeeper in flounce. STEVENS mixed metaphors in a chinchilla coat over a gift-wrapping dress. W dubbed MOORE's bustle and bicycle shorts "A Fright to Remember."

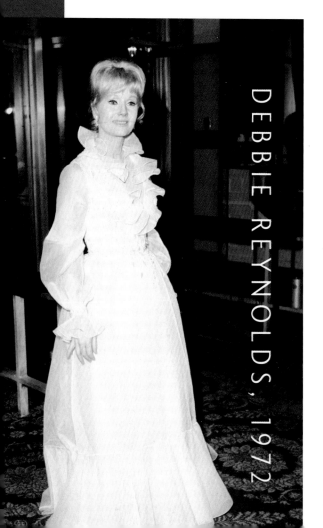

DEBBIE REYNOLDS, 1972

CONNIE STEVENS, 1967

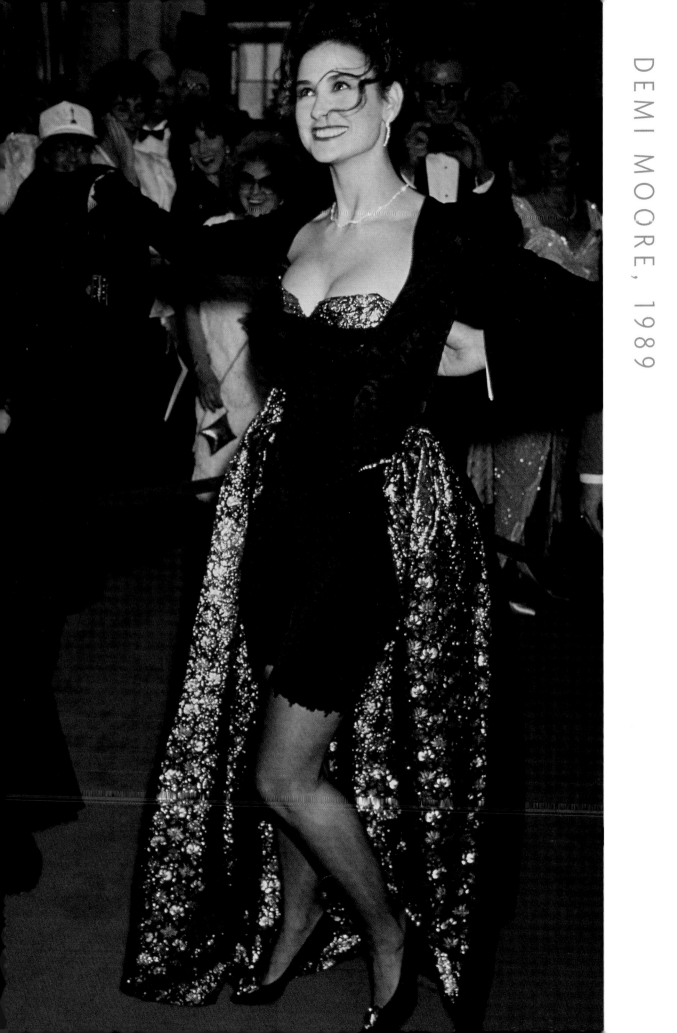

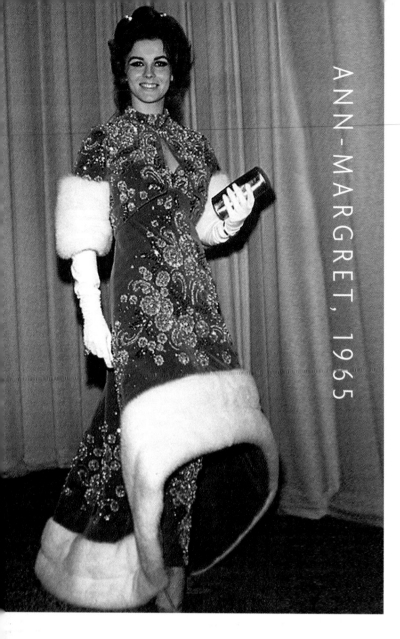

ANN-MARGRET, 1955

In a fur-trimmed concoction of gown over pants, ANN-MARGRET looked more Ice Capades than Oscar. CANNON was simply un-suitable. KEATON went la-di-da in an Annie Hall ensemble, pairing a Giorgio Armani jacket with pumps and anklets.

DIANE KEATON, 1978

DYAN CANNON, 1973

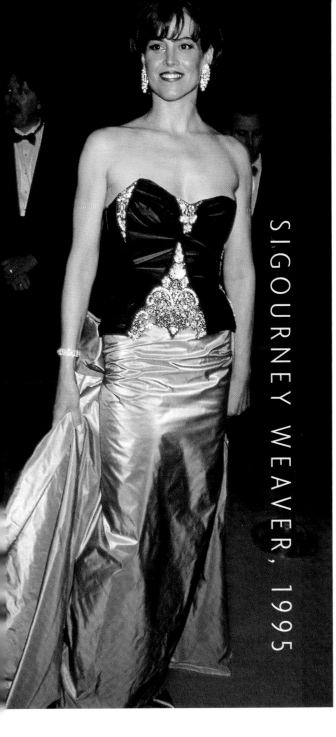

SIGOURNEY WEAVER, 1995

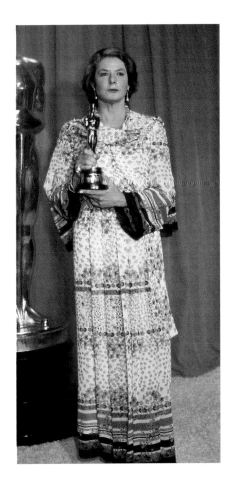

INGRID BERGMAN, 1975

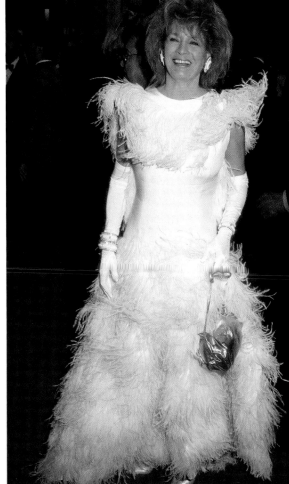

ANGIE DICKINSON, 1989

"I just wanted to be able to say, 'Sweetie, darling, it's Lacroix,'" said WEAVER of her ill-fitting silver-hooded bustier and skirt. Once a trendsetter, BERGMAN was way behind the curve in this busy bell-sleeved dress. Don't shoot! Critics called DICKINSON's feathery faux pas her "duck costume."

Worst

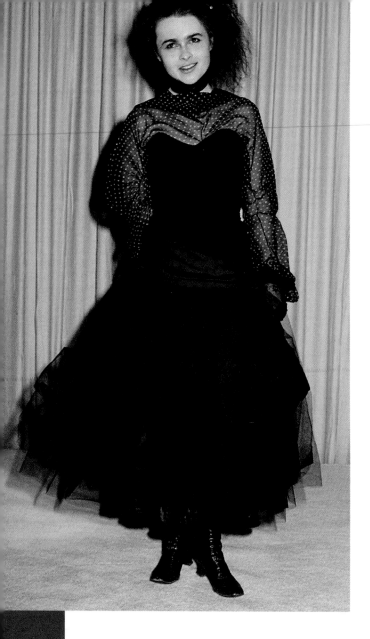

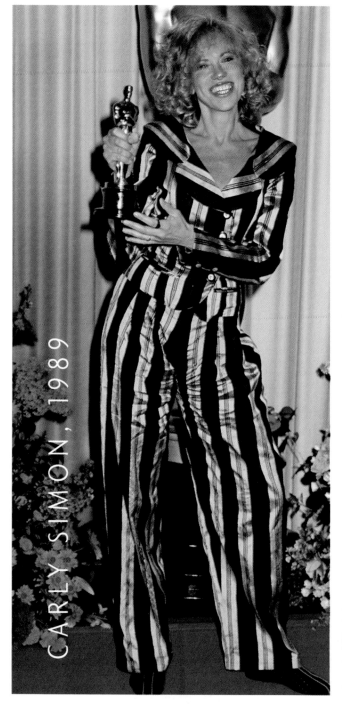

A Room with a View's
BONHAM CARTER *said
that this Vampira-goes-
to-the-prom dress cost
$60. She paid too much.
You're so veined: Inside*
Oscar *authors Mason
Wiley and Damien Bona
said Best Song winner*
SIMON'*s widely striped
outfit "resembled one of
Michael Keaton's costumes
in* Beetlejuice."

HELENA
BONHAM
CARTER,
1987

CARLY SIMON, 1989

Worst

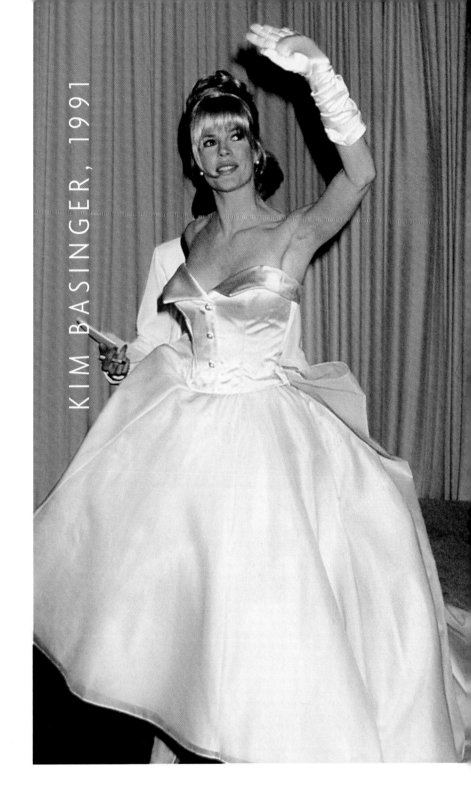

Curtsy, it's the queen. The train of BASINGER's strapless, button-front white satin ballgown was so long she needed an assistant to carry it. Tom Cruise had to refocus after seeing spots on then-wife ROGERS. Her dotted sheath sported a bow-tie belt and Carmen Miranda sleeves. Ay, caramba.

MIMI
ROGERS,
1989

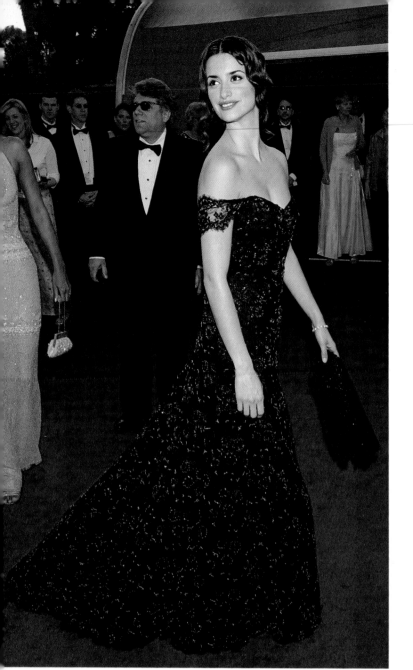

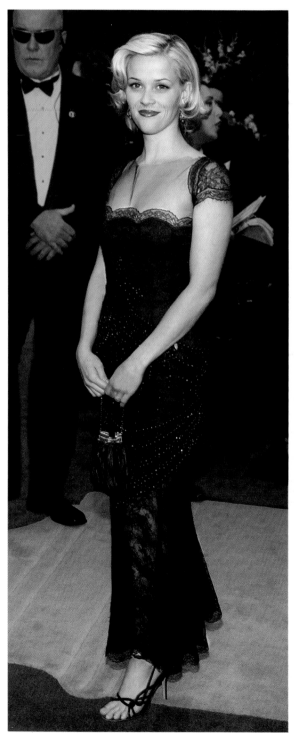

REESE WITHERSPOON, 2002

PENELOPE CRUZ, 2001

There was "a bit of a Spanish influence," CRUZ said of her lacy black off-the-shoulder Ralph Lauren. WITHERSPOON showed off her legally blonde locks in a delicate black beaded Valentino. BASSETT paired a white Escada with a floor-length evening coat. "It's old and it fit and I love it," said ZELLWEGER of this haute couture canary Jean Dessès from the 1950s.

Best

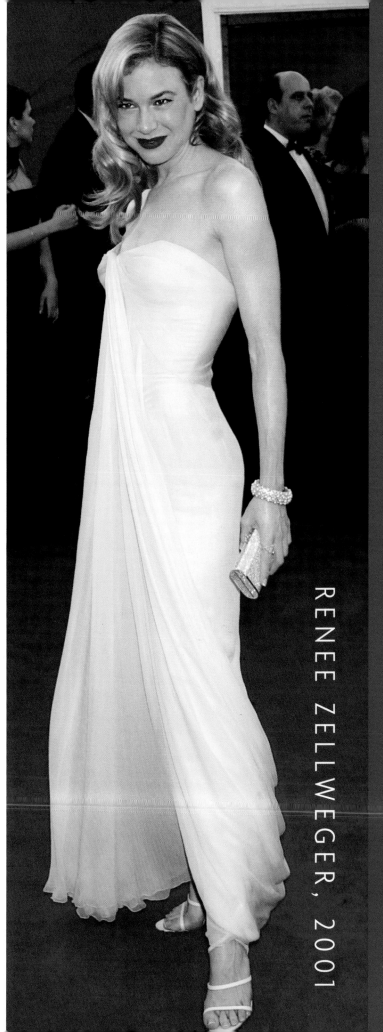

ANGELA
BASSETT,
1997

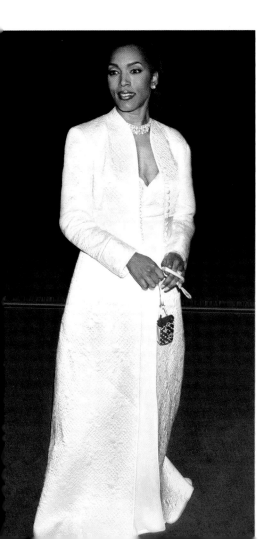

RENEE ZELLWEGER, 2001

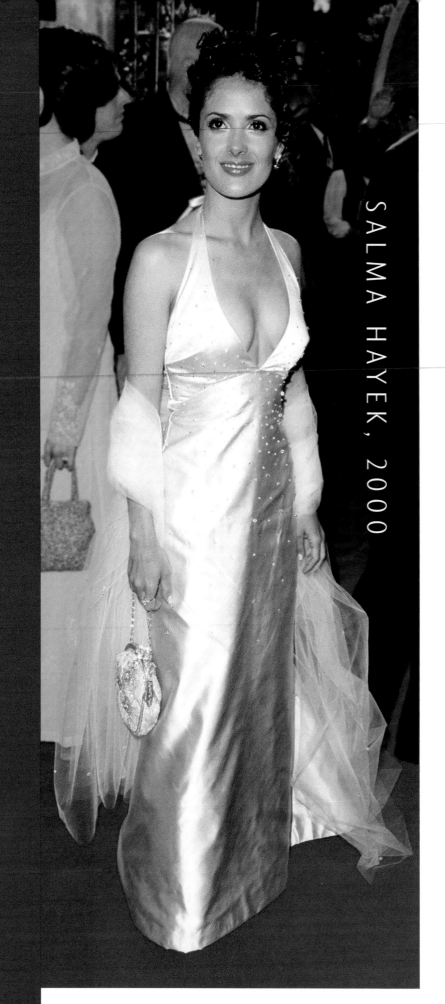

SALMA HAYEK, 2000

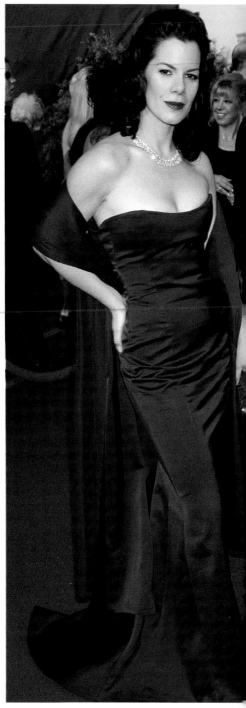

MARCIA GAY HARDEN, 2001

HAYEK *called her lavender Eric Gaskins gown with plunging neckline "very spring and soft."* HARDEN *got "old-world Hollywood glam" in this strapless crimson Randolph Duke.*

JADA PINKETT SMITH, 2002

Best

DAVIS *met with designer
Bradley Bayou five times before
appearing in this '50s-style silk-
satin ballgown.* PINKETT SMITH
*found her Lanvin-Castillo gown
in a New York City vintage shop.*

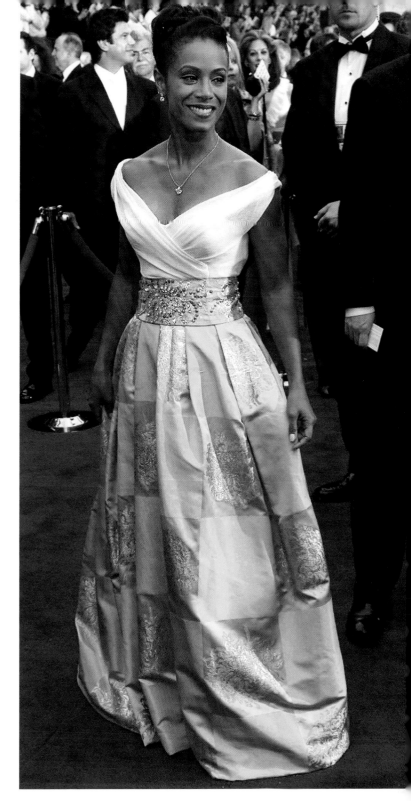

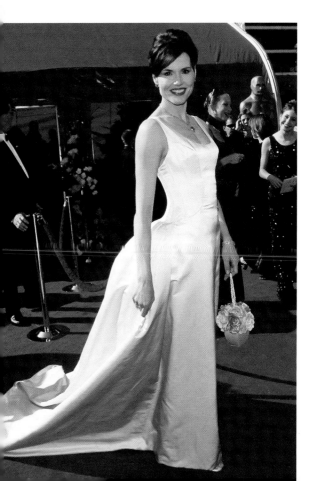

GEENA
DAVIS,
1999

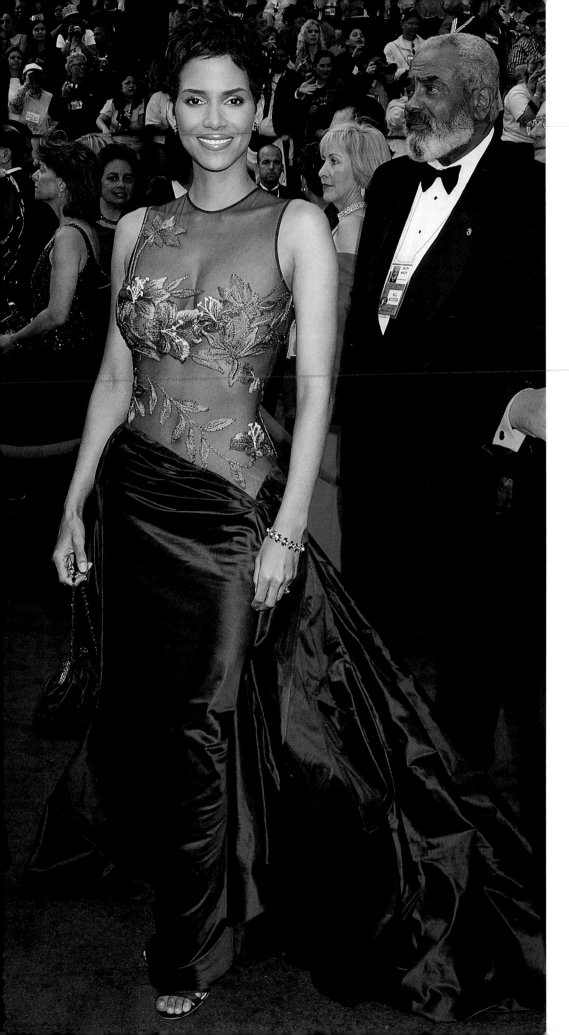

BERRY *looked like she was having a monster of a ball in this Elie Saab gown with wine-colored full silk taffeta skirt and mesh top with floral embroidery. "It was a one-of-a-kind, funky, artistic dress," said Phillip Bloch, her stylist. He picked right: Not only did Berry come away with the Best Actress Oscar, but she won raves from fashion critics around the world.*

HALLE BERRY, 2002

Best

MINNIE DRIVER, 1998

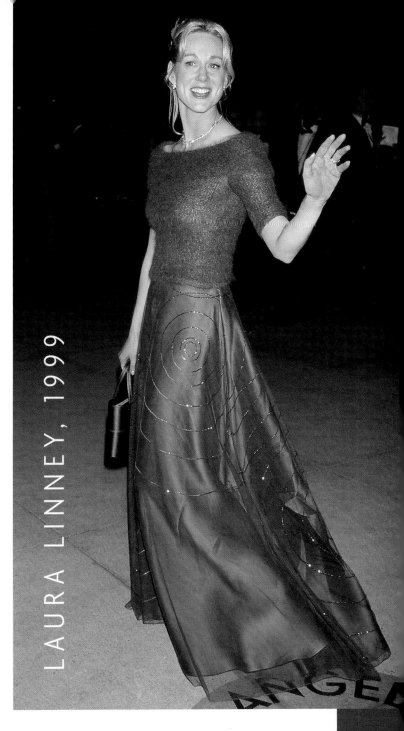

LAURA LINNEY, 1999

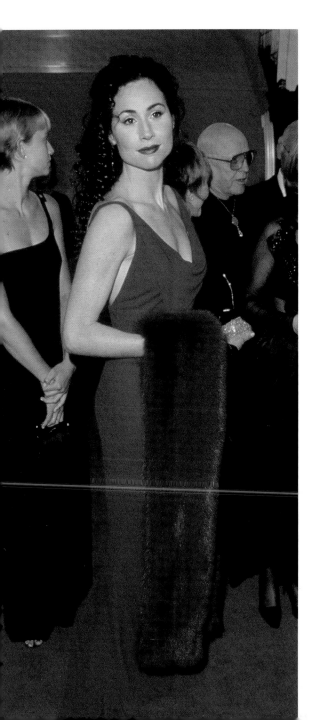

"I knew this was it," the smoldering DRIVER said of her ruby-red Randolph Duke (for Halston) jersey sheath with faux fur dyed to match. "You have to sparkle, not your dress." LINNEY knew she could count on Oscar favorite Randolph Duke for this sophisticated but soft navy sweater and skirt, a pairing similar to the one Claire Danes had worn to the ceremonies in 1997.

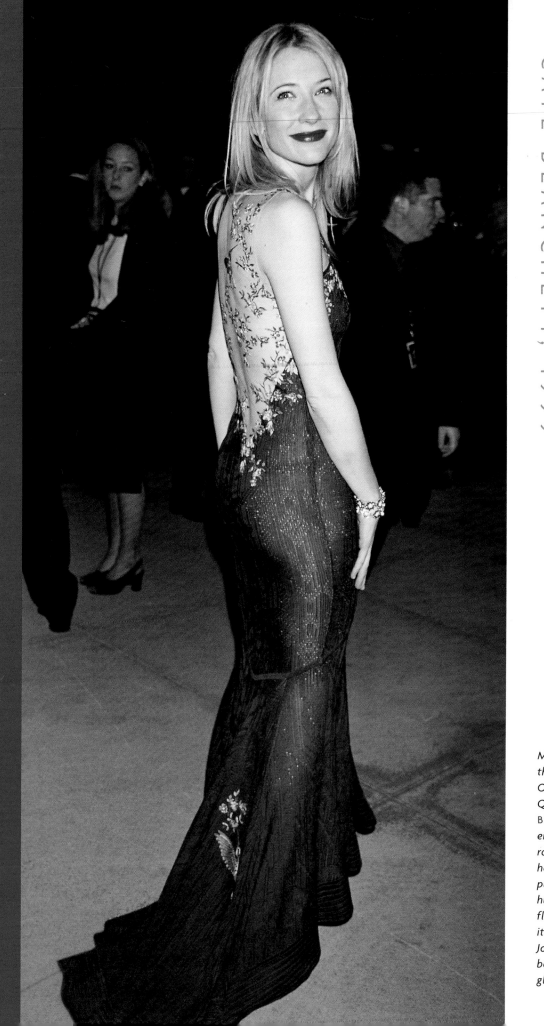

Maybe she didn't win the Best Actress Oscar for her role as Queen Elizabeth, but BLANCHETT looked enough like fashion royalty to take a few heads off. Her gorgeous purple knit gown, with hummingbirds and flowers embroidered on its sheer back, was by John Galliano. Added bonus: "It fits like a glove," said the actress.

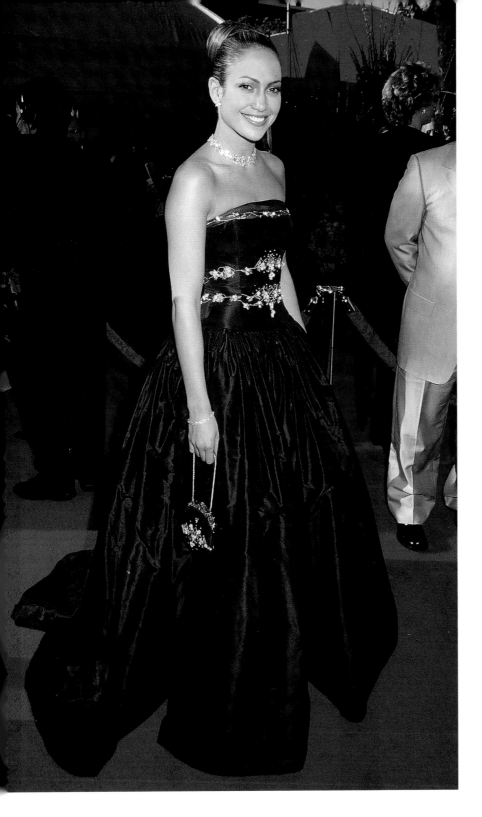

"I thought it would be perfect for tonight," LOPEZ *said of her princess-like Badgley Mischka.* WEAVER *had been shocked to learn in 1995 that Prada made evening dresses. She got over it. Her aubergine silk taffeta gown was a stunner.*

SIGOURNEY WEAVER, 1998

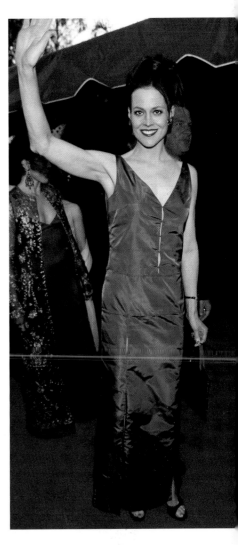

JENNIFER LOPEZ, 1999

Best

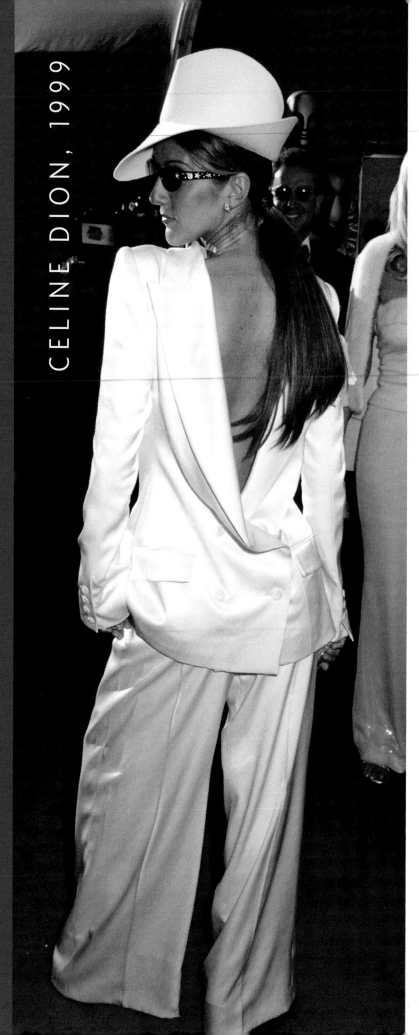

CELINE DION, 1999

Even the $25,000 diamond-dusted shades couldn't dim the disaster of DION's Galliano for Dior reversed tux jacket and Dick Tracy topper. Fargo's MCDORMAND perpetrated a fashion felony in vermilion Vera Wang. Underpants alert! HUDSON's Stella McCartney for Chloe was way off-key. What was A Beautiful Mind's CONNELLY thinking when she chose this seen-better-days Balenciaga?

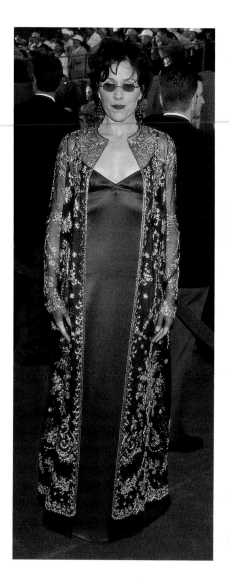

FRANCES
MCDORMAND
1998

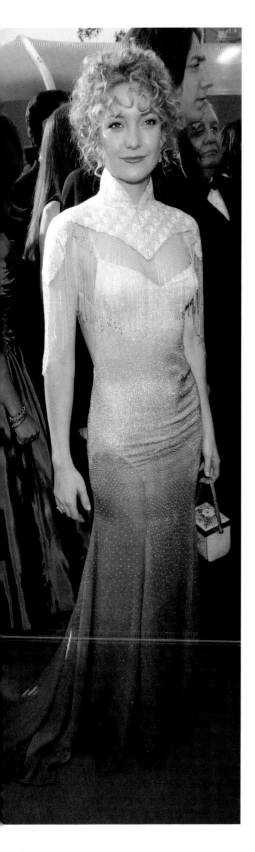

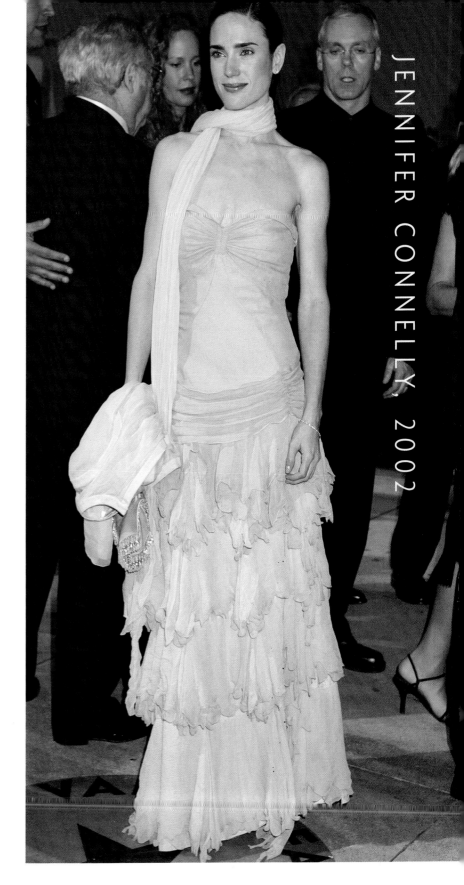

JENNIFER CONNELLY, 2002

Worst

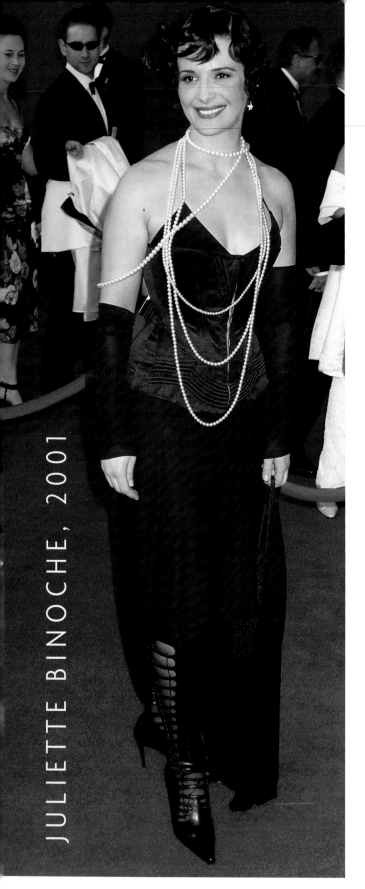

JULIETTE BINOCHE, 2001

BINOCHE *said she was "a modern Lulu" in her dominatrix-style Gaultier satin corset and knee-high boots.* HUNTER *couldn't go home for the holidays in this lacy shift by Vera Wang.*

HOLLY
HUNTER,
1999

Worst

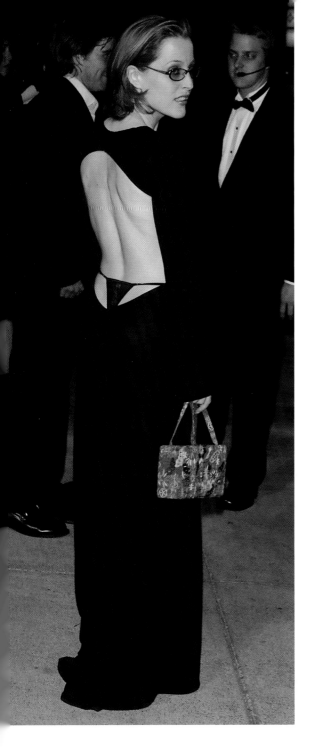

GILLIAN ANDERSON, 2001

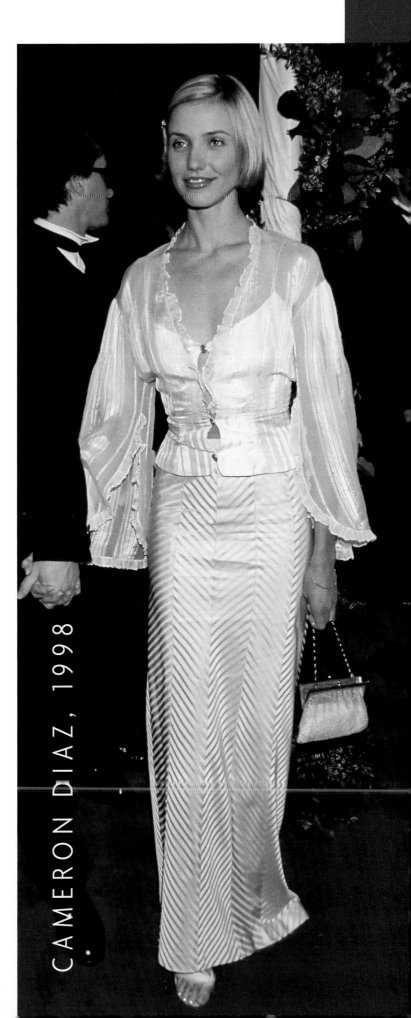

CAMERON DIAZ, 1998

Is it cold or is it just me?
ANDERSON *earned an*
X for this dorsal deviation
by Eduardo Lucero. A critic
said DIAZ, *in Galliano,*
looked like "a ragpicker."

Worst

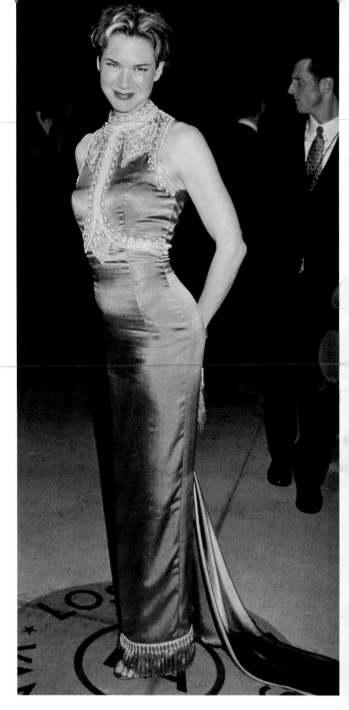

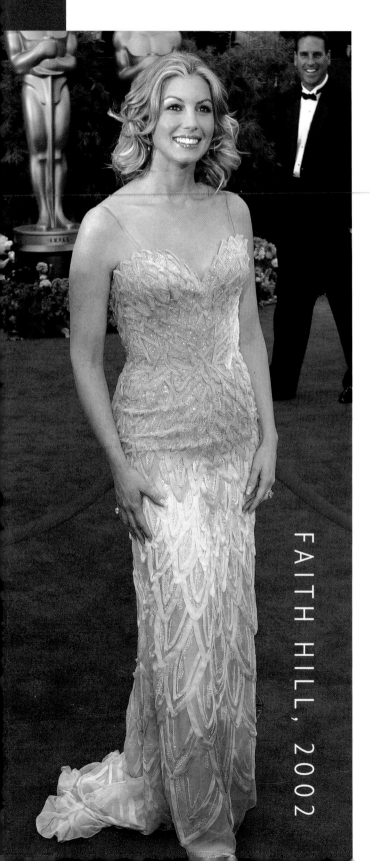

FAITH HILL, 2002

RENEE
ZELLWEGER, 1999

HILL *sang the* Pearl Harbor *theme but bombed in this ice-pop-hued Versace. "It's my first Oscars," said* ZELLWEGER *of her lumpy, shrink-wrapped L'Wren Scott. That explains it.*

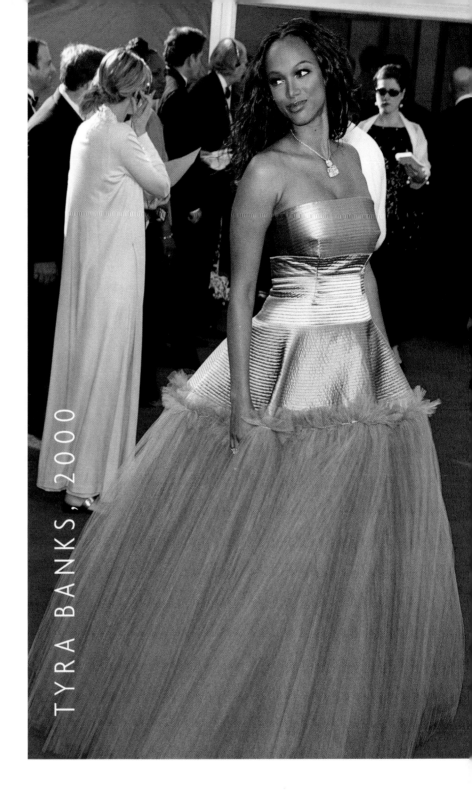

HOUSTON was a stitch in this scoop-necked Pamela Dennis. Does this make me look fat? BANKS has one of the world's best bodies, but it was hidden in this voluminous and hippy Vera Wang.

WHITNEY HOUSTON, 1999

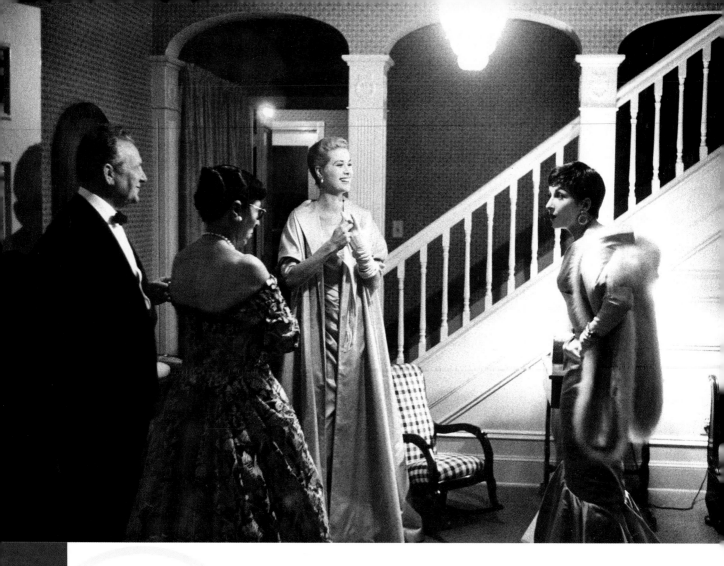

It Happened One Night

UNDER THE APPRAISING EYE
of designer Edith Head (above,
with glasses), Best Actress nominee
Grace Kelly prepared to leave
home for the ceremony with
producer Don Hartman and
ballerina pal Renée Jeanmaire in
1955. Last-minute madness: On
Oscar afternoon 2002, Jane
Seymour (inset) was fitted into this
crimson Joanna Mastroianni gown.

WHERE'S THE HAIR DRYER? IS THE STYLIST
stuck in traffic? Who's got the baby wipes?
Baby wipes? "They're good for cleaning
your armpits," said 1996 Best Actress
Frances McDormand. The stars have all
year to plan for Oscar night, but some-
how it all comes down to the last minute.
Some handle it with a cool reserve, like
Marlon Brando and Grace Kelly. But for many
it's an ordeal, what with the loaner jewels, the limo and the
gown. Oh, God, the gown. "All I've eaten today is a protein
bar," said presenter Angela Bassett, poured into a strapless
Escada in 2000. "I'm going to die before the show is over."

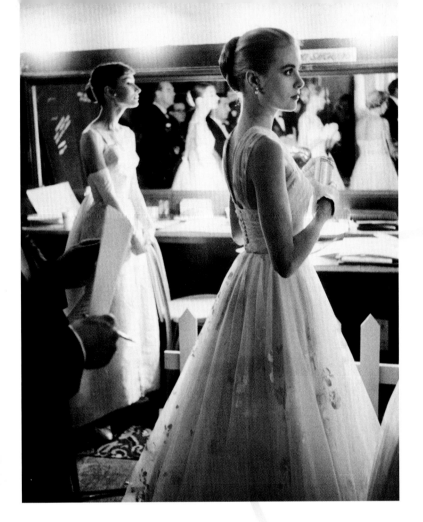

THE WAITING GAME: *Backstage at Hollywood's RKO Pantages Theater, 1956 presenters Audrey Hepburn and Kelly maintained a relaxed (and gloved) elegance while getting ready to go on. Hardly a wild one, a calm Best Actor nominee Marlon Brando was wished luck by two* Guys and Dolls *extras as he left the MGM lot on Oscar afternoon in 1955.*

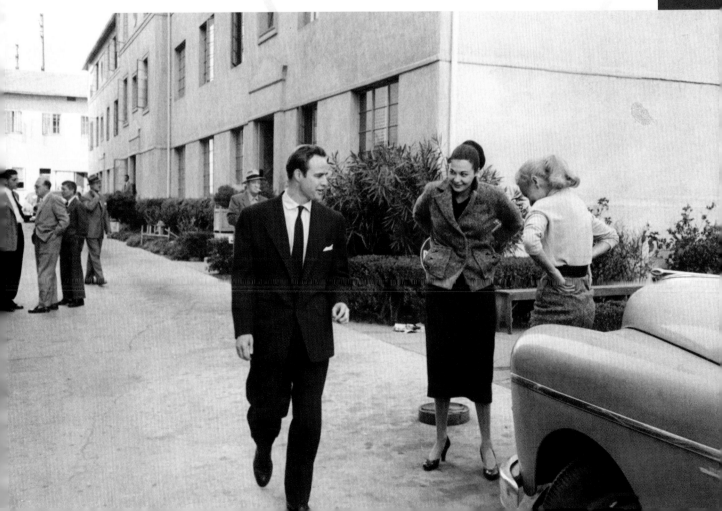

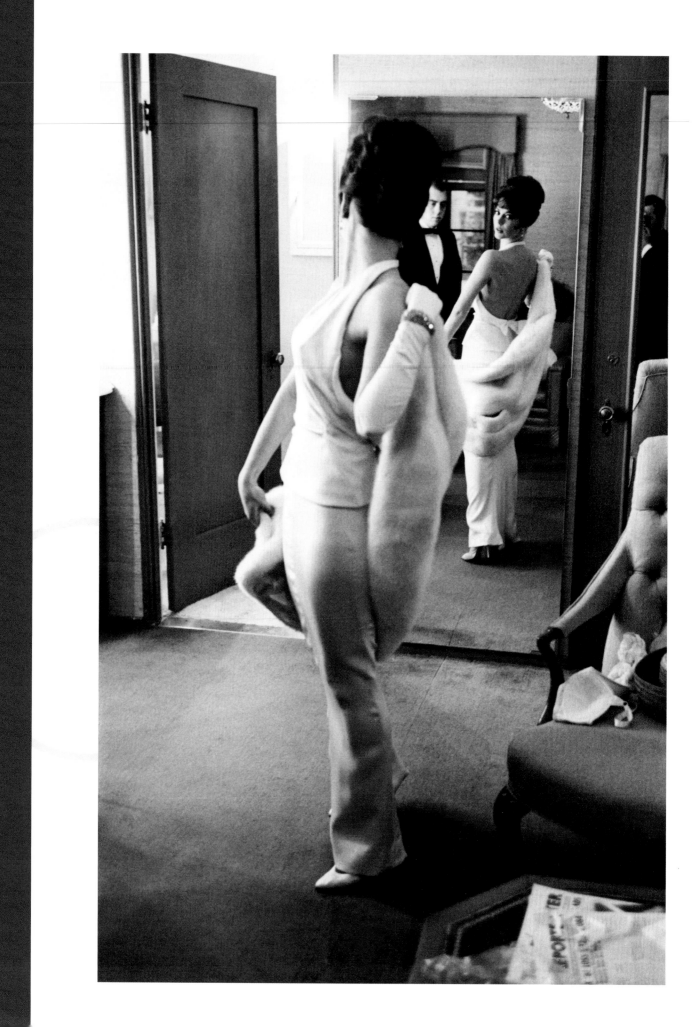

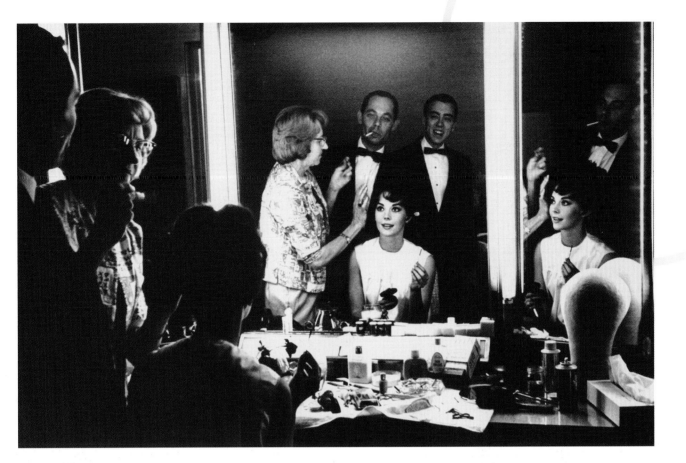

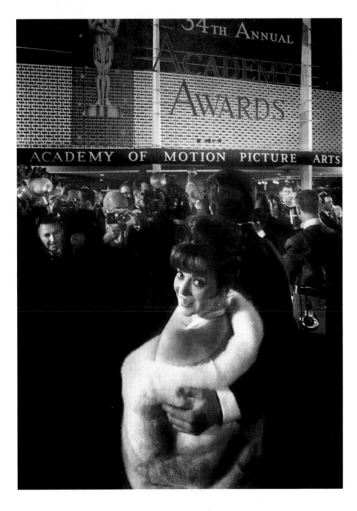

DRESSING A DIVA WHEN *the studios ran Hollywood was a corporate act. In 1962, Best Actress nominee Natalie Wood admired her white gown and ermine stole in a Warner Bros. dressing room. A stylist did her hair while suits happily looked on. Wood took a turn on the red carpet before sitting with her bespectacled* Splendor in the Grass *costar Warren Beatty.*

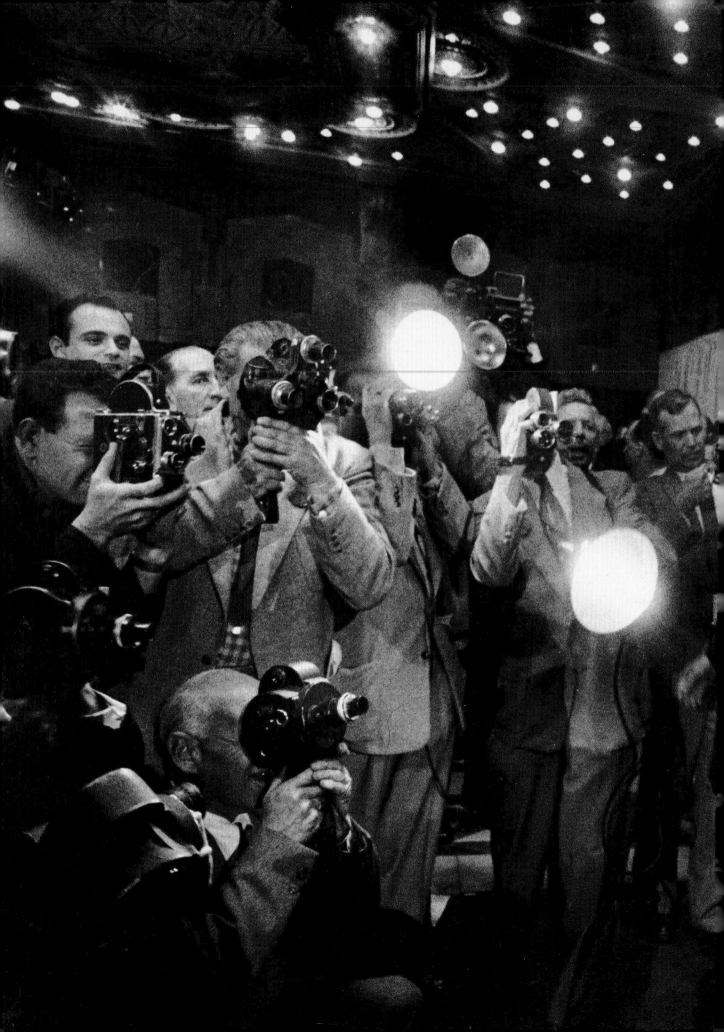

lost his poise—or wrinkled his shirt—Brando was bewildered on the 1955 red carpet when he lost track of his father, Marlon Sr., who was with him. Later that evening, he won Best Actor for On the Waterfront.

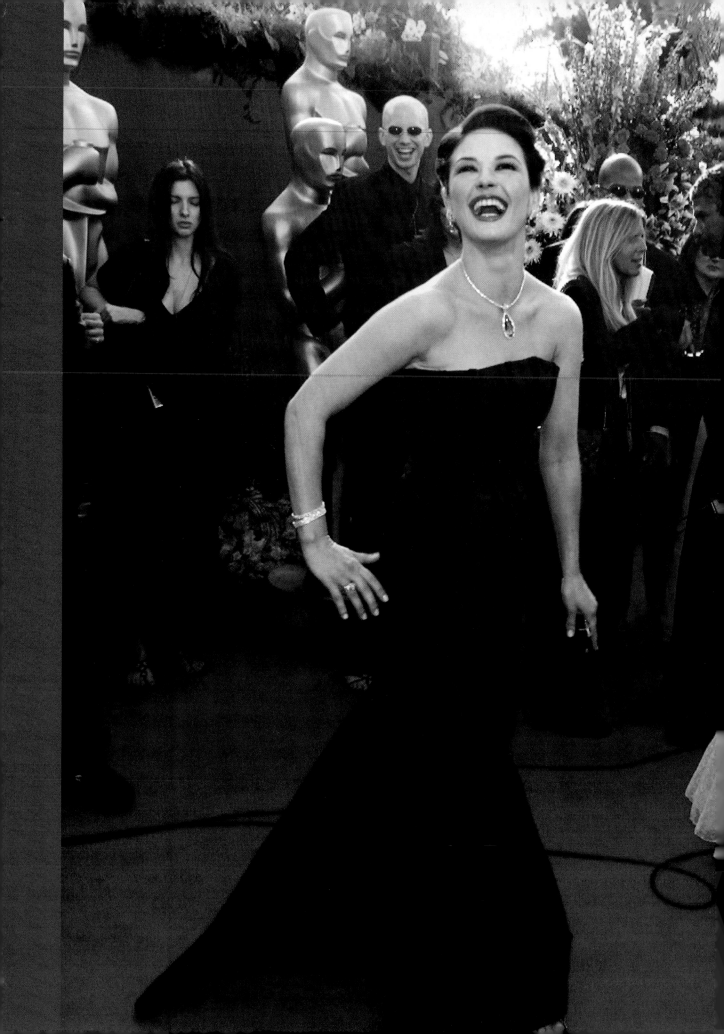

ALL HANDS ON DECK:
Minutes before showtime in 2001, Catherine Zeta-Jones stopped traffic with a Versace bustier gown and husband Michael Douglas. And she nicely explained what the pre-Oscar buildup is all about: "I pretty much feel like Cinderella."

In the Heat of the Night

TRY THE LOBSTER REMOULADE! ANYTHING great in the goody bag? Are Warren and Shirley getting silly over there? Who's that talking to Gwyneth? Let the games begin: Seventy-five years into its glamorous history, Oscar still cries out for post-Awards celebrations. After a ceremony that feels like it runs a week, the stars are ready to let down their hair extensions, loosen their foundation garments and eat, drink, air-kiss and schmooze until dawn. Maybe a few go home early, but most echo last year's Best Actress Halle Berry. "We're going to party," she announced, giving voice to one of Oscar's most enduring traditions. "Probably until noon tomorrow."

PASS THE DIP. BOTH presenters in 1961, these showbiz siblings had a lot of pent-up energy to work off after sitting through the Awards ceremony. Shirley MacLaine, sparkling in sequins, and Warren Beatty, proper in white tie, staged their own brother-and-sister act at the Governors Ball, held at the Beverly Hilton Hotel.

PALS WINONA RYDER *and* Boys Don't Cry's *Hilary Swank posed prettily after the ceremony in 2000.* Chocolat *costars Juliette Binoche and Dame Judi Dench whooped it up at the Governors Ball in 2001.*

"BENJAMIN IS MY *inspiration," declared Julia Roberts, who was giddily happy at the Governors Ball after her Best Actress win for Erin Brockovich in 2001. Wearing vintage Valentino couture, she and then-boyfriend Bratt kissed, danced and grinned the night away.*

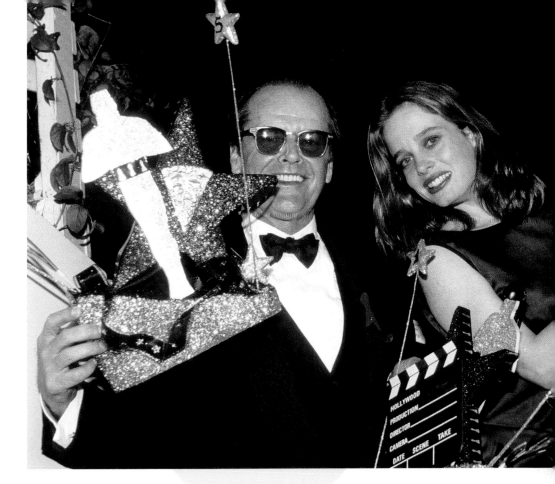

JACK NICHOLSON AND *then-girlfriend Rebecca Broussard made silly with table centerpieces in 1993 at one of Swifty Lazar's fabled Oscar parties at Spago.*

PHOTOGRAPHERS ASKED *Best Acting nominees Judy Holliday, José Ferrer and Gloria Swanson to sit together during the New York City Oscar party at La Zambra restaurant in 1951. Sole loser Swanson later called the stunt "a tasteless exercise, even for the press."*

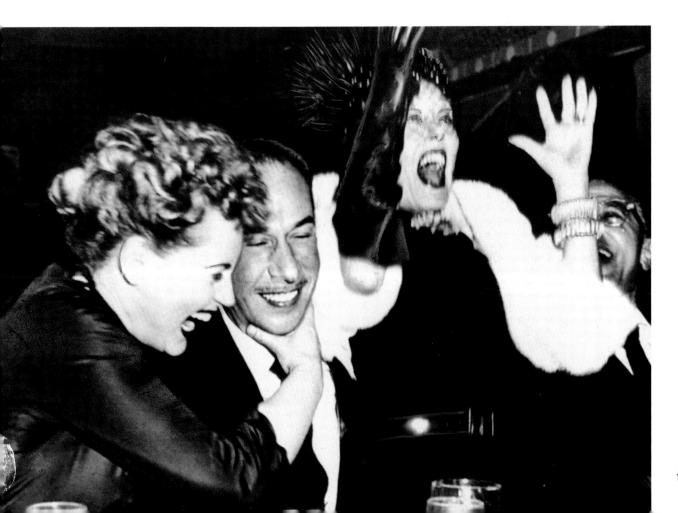

TANNED AND A TAD
*top-heavy, Elizabeth Taylor
provided the view at a 1970
do while then-husband
Richard Burton gazed on.
Elated Best Actor Nicolas
Cage enjoyed a passionate
face-off with then-wife
Patricia Arquette at the
Governors Ball in 1996.*

JENNIFER LOPEZ DREW *plenty of stares in her see-through Chanel gown as she and Macy Gray made the scene at the Vanity Fair party in 2001. Lopez had just broken up with Sean "P. Diddy" Combs but managed to avoid running into him at the affair.*

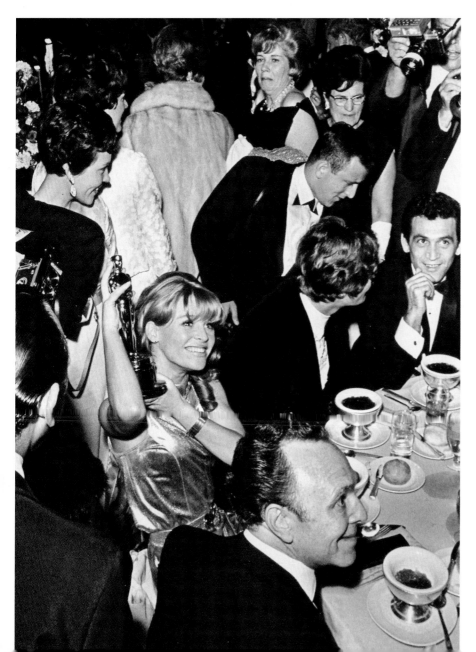

SHOULDERING A *burden, but a happy one, Julie Christie celebrated her Best Actress win for Darling at the Governors Ball in 1966. With her glittering gold jumpsuit and those shining blonde locks, she was glowing brighter than Oscar.*

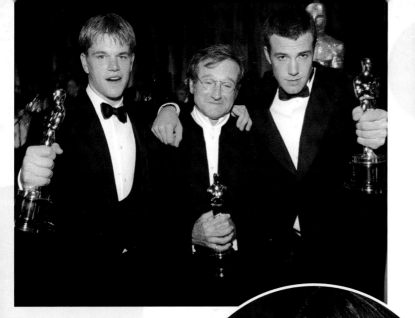

WINNING TRIO MATT
Damon, Robin Williams and Ben Affleck celebrated at the Governors Ball in 1998. Elton John got frisky with Elizabeth Hurley at his IN STYLE *party in 2000; Dennis Rodman played down to Billy Crystal at the* Vanity Fair *party in 1997.*

THE POWER TABLE AT MAPLE
Drive in 1994 included (from left) Kate Capshaw, Elton John, Bruce Springsteen and wife Patti Scialfa, Rita Wilson's sister Lily Reeves, Tom Hanks, Rita Wilson and Steven Spielberg.

MY OSCAR WAS this *big. In 1963, a year after winning for* Two Women, *Sophia Loren talked it up in a shaggy collar at a post-Oscar dinner with her director husband, Carlo Ponti.*

SINGING FOR THEIR supper: *After performing together at the Awards in 1999, Dior-clad Celine Dion and Italian tenor Andrea Bocelli sat down for some chat and chew at the Governors Ball. Happily, the flak over her outfit (see* Best & Worst Dressed) *didn't seem to affect Dion's appetite.*

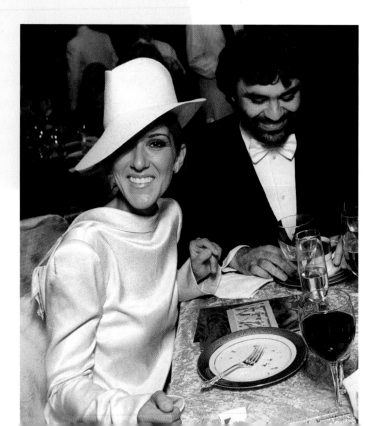

THE PURPLE FUR WAS FAUX, THE
partying was real. Whitney Houston
(wearing J. Mendel) and husband
Bobby Brown had a blast in 2001 at
both the Elton John/IN STYLE
party at Moomba and here at the
Vanity Fair party at Mortons.

STEP CLASS: TWO
members of America's acting
royalty, Lauren Bacall and
Kevin Spacey, took a turn on
the floor together at the 1997
Governors Ball. Bacall had
just lost in the Best Supporting
Actress category (to Juliette
Binoche), but she put on a
good face—finding comfort,
perhaps, in her dance partner's
black velvet frock coat.

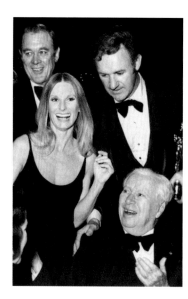

FOLLOWING HER win as Best Actress, Halle Berry and her ballad-belting husband Eric Benét set out for a long night of partying in 2002. First stop: the Governors shindig, where they looked like they were having, yes, a monster of a ball.

AFTER A 20-YEAR EXILE FROM THE U.S., Charlie Chaplin (seated) got an honorary Oscar in 1972 and celebrated with Ben Johnson, Cloris Leachman and Gene Hackman at the Governors Ball. Geoffrey Rush got a rise out of Nicole Kidman and Tom Cruise at the 1997 VF party.

GREETING AN OLD *friend (they'd both been in TV's* Faerie Tale Theatre*), Susan Sarandon said hello to Christopher Reeve (with wife Dana) at the 1996 Governors Ball. Foxy Daisy Fuentes and Pamela Anderson shared a giggle with Jim Carrey and Tim Allen at the 1999 VF party.*

WINNING BEST ACTRESS *for* The Country Girl *in 1955, Grace Kelly said that the thrill "prevents me from saying exactly what I feel." She was still mesmerized by Oscar at a Romanoff's dinner. Titanic's Leo DiCaprio and Sea of Love's Ellen Barkin rode the wave at the 1994 Vanity Fair party.*

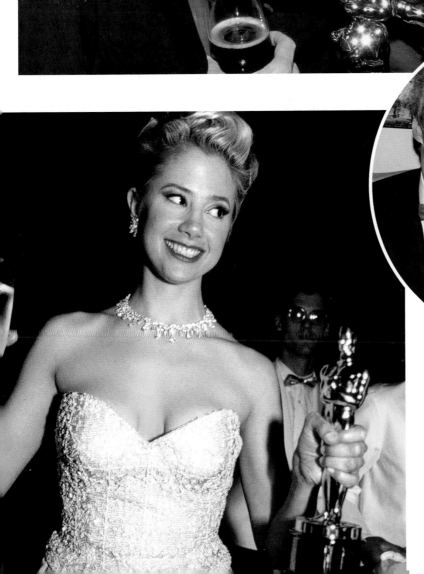

MUGGING SHOTS: *FARGO'S*
Steve Buscemi (top left), Joel Coen
and Frances McDormand chill at
Elton John's 1997 bash. Making his
day, Emma Thompson joins Clint
Eastwood (in his lucky snakeskin
tie) at 1993's Warner Bros. party.
Mira Sorvino has her hands full at
the 1996 Governors Ball.

"SHE WAS JUST SO *wonderful tonight,*" *said Blythe Danner, celebrating with daughter Gwyneth Paltrow at the 1999 Governors Ball. Gowned in pink Ralph Lauren, the 26-year-old won Best Actress for her cross-dressing romp in* Shakespeare in Love.

CHASED AT CHASEN'S: BOUNTIFUL *in black, Catherine Zeta-Jones gets a headlock on her future* Entrapment *costar, a jacketless and sleepy-eyed Sean Connery, at a 1998 post-Oscar party at Chasen's. Two year later, the venerable Hollywood eatery finally closed its doors.*

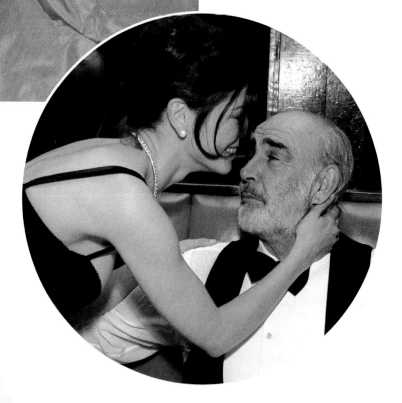

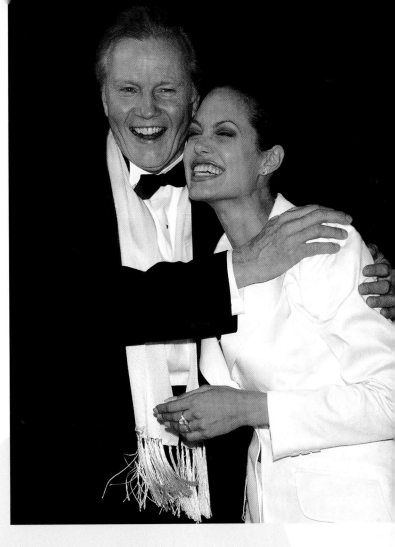

GIRL, INTERRUPTED: IT HAD BEEN A WHILE *between parties, but Angelina Jolie was no newcomer. She accompanied dad Jon Voight to the Governors Ball in 1986 (she was 10) and to the Vanity Fair party in 2001.*

FOOTLOOSE: THOSE *long Oscar nights can be tough on the tootsies, so LeAnn Rimes and Andrew Keegan (10 Things I Hate About You) put themselves in a sole-ful mood at Elton John's 2001 AIDS benefit party at Moomba.*

INTO THE NIGHT: A
tired Audrey Hepburn, 24,
who was starring on
Broadway, finally left
New York City's Century
Theatre (eastern site of the
1954 Oscar telecast)
after winning Best Actress
for Roman Holiday.
Recommended next stop:
breakfast at Tiffany's.

Photo Credits